TRAFFORD

THE POSTCARD COLLECTION

Steven Dickens

AMBERLEY

For Saul – Let no one seek his own good, but the good of others.

First published 2019

Amberley Publishing
The Hill, Stroud, Gloucestershire, GL5 4EP
www.amberley-books.com

Copyright © Steven Dickens, 2019

The right of Steven Dickens to be identified as the
Author of this work has been asserted in accordance with
the Copyrights, Designs and Patents Act 1988.

ISBN 978 1 4456 9269 2 (print)
ISBN 978 1 4456 9270 8 (ebook)

British Library Cataloguing in Publication Data.
A catalogue record for this book is available from the
British Library.

Typesetting by Aura Technology and Software
Services, India. Printed in Great Britain.

CONTENTS

INTRODUCTION

This volume deals with mainly early twentieth-century postcard images of the towns and suburbs that make up the modern Metropolitan Borough of Trafford, established in 1974. The volume begins with Flixton; then Urmston and Davyhulme (including Barton, Carrington and Partington); Stretford and Old Trafford; Ashton-on-Mersey; Sale and Brooklands; Bowdon and Dunham Massey (including Hale, Hale Barns and Timperley); and lastly Altrincham. The selected postcards cover many publishers and photographers. Well known in Urmston was the business of J. Wride, who produced many postcard images of Flixton, Urmston and Davyhulme in the early part of the twentieth century, with twenty-one of his postcards reproduced here. They give us a view of the district before the wholesale development of the 1930s turned the area from a selection of rural villages into a suburb of the city of Manchester. Other publishers for Flixton, Urmston and Davyhulme are E. Mather, Post Office, Flixton 4; Whittaker & Co., Irlams o' th' Height/Pendleton 4; J. H. Smith, Post Office, Flixton 2; AW Series 2; S. Butler, Altrincham 2; Harold Clarke 2; CE Ardern, Lymm 1; 'Alumino' 1; Baur's Series 1; Wonder Series 1; Empire Series 1; Wilkinson, Manchester 1; 'GD & DL' 1; Valentine's XL Series 1; with nine of unknown origin. The postcard collection of Stretford and Old Trafford give us images of an essentially established suburb and industrial area close to the Manchester Ship Canal, although one or two images, particularly of Trafford Hall, allude to its manorial past and its former importance as a centre of pig production and distribution. Many of the Stretford postcards are produced by a local publisher, A. Hargreaves, of Edge Lane, Stretford 7; Grosvenor Series 2; Valentine's Series 2; Wrench Series 1; 'AHC' 1; JEB Series 1; 'JTB' 1; Dainty Series 1; 'White House Series' 1; with ten of unknown origin.

The Ashton-on-Mersey and Sale districts are extensively covered by the Birkenhead's Series of colour postcards. These form a detailed library of the area in the early part of the twentieth century and, like Wride in Urmston, they were local stationers and business owners. For Ashton-on-Mersey we have J. Birkenhead, Sale 7; Birkenhead's Series (colour) 6; Wrench Series 1; Fielding's Series 1; 'FSS' 1; with 2 of unknown origin. For Sale we have Birkenhead's Series (colour) 4; Wrench Series 4; Fielding's Series 3; J. Birkenhead, Sale 2; Valentine's Series 2; with 5 of unknown origin. Bowdon and Dunham Massey includes Hale, Hale Barns and Timperley, with S. Butler, Altrincham 10; Valentine's Series 4; Frith's Series 3; Wrench Series 3; Grosvenor Series 1; L.F. Series 1; Perfection Series 1; Victoria Series 1; Timperley Series 1; Lilywhite 1; with 1 of unknown origin. Lastly, Altrincham consists of Valentine's Series 9; Frith's Series 4; S. Butler, Altrincham 3; Wrench Series 2; 'FSS' 1; Lilywhite 1; Harold Clarke 1; 'New Framed' Series 1; with one of unknown origin. Many of these are reproduced in colour and show the area at its tranquil and picturesque best before development and motor traffic became the 'feature' they are in the twenty-first century. Most of these postcards centre on the traditional 'heart' of the old market town of Altrincham, around the Old Market Place, Market Street and George Street, which are still important centres today. As with Sale and Ashton-on-Mersey, the A56 Chester Road is featured extensively. First established as a route between Manchester and Chester by the Romans, the highway continues to be influential and is a main route between the M6, M56 and M60 motorways. The overall aim of this book is to show the development of the Metropolitan Borough of Trafford through a selection of postcard images, of which there are many comparable choices! It has also allowed me to make some minor amendments to my original research. I hope the reader enjoys the result.

CHAPTER 1

FLIXTON, URMSTON AND DAVYHULME

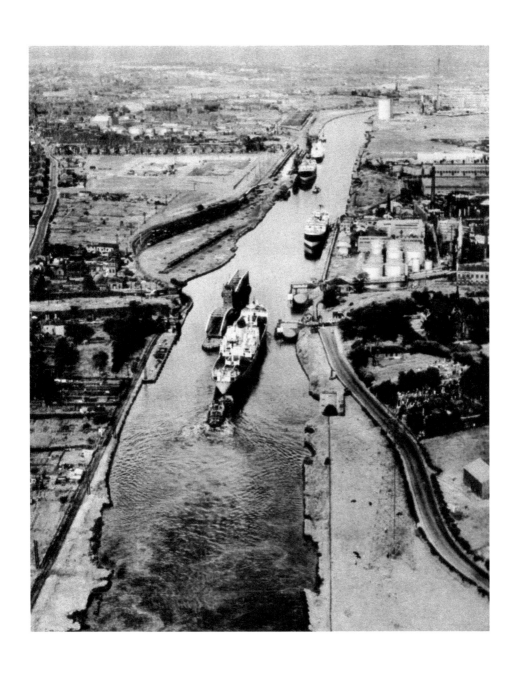

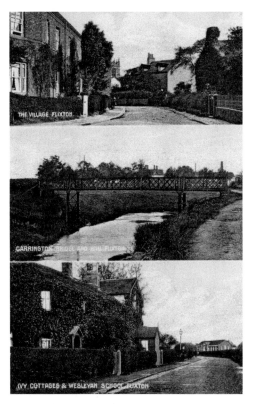

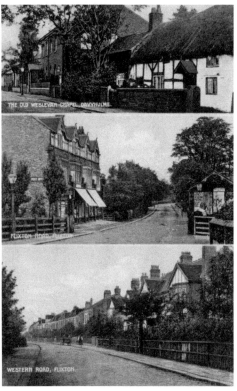

Flixton 'Multi-views' 1909 & 1911

The above colour 'Multi-view' postcard
gives us views of the village at Flixton and
St Michael's parish church, top; Carrington
Bridge and hall, at Flixton, middle; and Ivy
Cottage and the Wesleyan school, Moorside
Road, bottom. The Fold is now located at
the site of the school, and together with the
cottages is the site of a bungalow. Further
along Moorside Road we have the now
demolished old Wesleyan chapel and Wood's
Farm, top, on the 'Multi-view' postcard below;
Flixton Village and Millott's Barn, middle; and
Western Road, below, published by Wride.
These views are also available as single
postcards published by Wride of Urmston
(and others). The Wride family's shop was
a stationer business that included picture
framing, book binding and printing services.
In 1898, this was under the name of James
Wride, at Flixton Road, Urmston. The Wride's
business went into voluntary liquidation in
1937, with the family living locally. Wride
also had a business premises at Lostock Road,
Davyhulme, which ran as a radio dealership.
These were introduced to the business in
1925, with photographic equipment added to
the stationery section. They claim to have sold
the first radio set bought in Urmston.

Flixton Road & Irlam Road Junction leading to Boat Lane, 1923, & Flixton 'Multi-view', 1916
The 'Multi-view' below includes Western Road; St Michael's Church; the junction of Flixton
Road and Irlam Road, leading to Boat Lane; and winter in Flixton at the footpath on Western
Road, which connected with Irlam Road. Boat Lane signposted and top right on the 'Multi-view'
(and above postcard) is now part of Irlam Road, which was originally made up of three separate
parts: Miller's Lane, Green Lane and Boat Lane. It led west towards the Irlam Ferry (1712–1975)
and the Manchester Ship Canal, which claimed 114 acres of Flixton for Irlam, due to the altered
course of the waterway in 1895. Towngate Farm, Boat Lane Farm and Warburton Wall Farm all
lay along this section of Boat Lane. Irlam Soap and Candle Works and the Irlam Steel Works
provided employment for many once the canal was established.

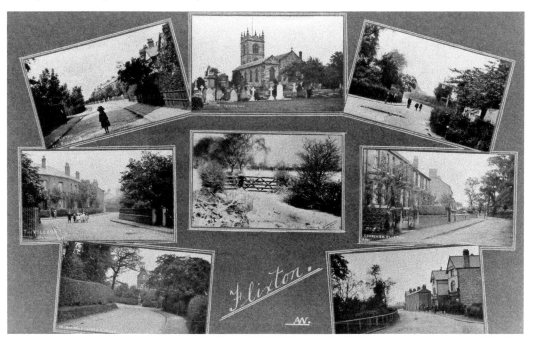

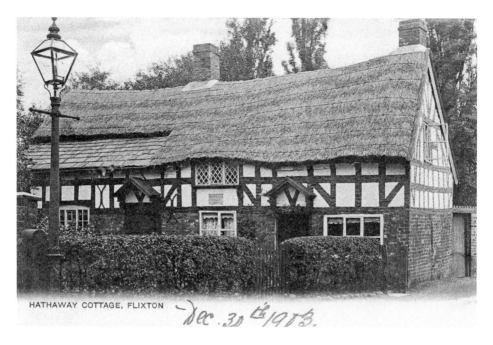

HATHAWAY COTTAGE, FLIXTON ꟾ Dec. 30ᵗʰ/1903.

Hathaway Cottage, Flixton Road, 1903, & Junction Cottage, Flixton Road & Irlam Road, 1906
Based very loosely on the style of the Hathaway and Shakespeare cottages in Stratford-upon-Avon, these were built in 1721 (above). The cottages were demolished and replaced by the caretaker's house at the John Alker Hall, Flixton Road, 1927, which was then replaced by new housing around 2014. Junction Cottage (below left), which was half-timbered and had a thatched roof, sat opposite these cottages, on the south side of Flixton Road and opposite its junction with Irlam Road, where Holly House was located. On the adjacent corner of Irlam Road was the Smithy, which also incorporated a small shop. The Smithy was demolished in 1953. The field behind Holly House (now Whitegate Park) was known as Smithy Field. The gable end of Hathaway Cottage can be seen (far right) fronting Flixton Road.

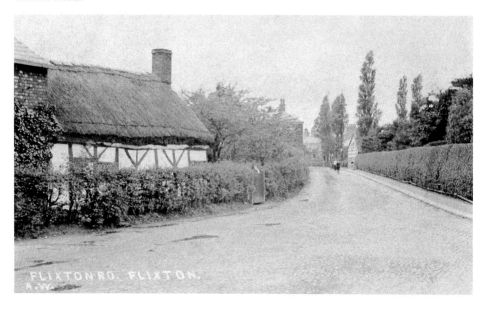

FLIXTON RD. FLIXTON.
A.W.

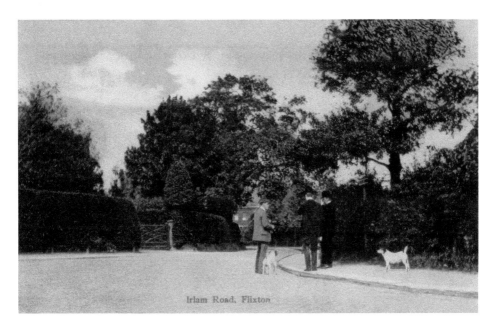

Irlam Road, Flixton

Flixton Road & Irlam Road Corner, 1905, & Irlam Road, Ardnadam & Overdale *c.* 1900
Known as Holly (Hedge) or Newton's Corner, it was noted for neat hedges, on the left
of both postcards. The residence here, Holly House, was once owned by Margaret Ellen
Newton (1843–1912) who donated the clock faces to St Michael's Church. In 1950 the land
was purchased by the Diocese of the Roman Catholic church, with Holly House Drive
later constructed here. The large semi-detached houses shown in the postcard below are
Overdale on the right and Ardnadam, named after a west coast of Scotland village, on
the left. They are located on the north-east side of Irlam Road and were built by the Stott
family around 1890, with Samuel Stott briefly living at Overdale. It was also home to
John Alker, after whom the hall on Flixton Road is named. He died at Overdale in 1920.

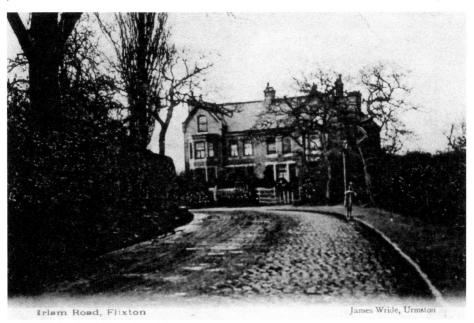

Irlam Road, Flixton James Wride, Urmston

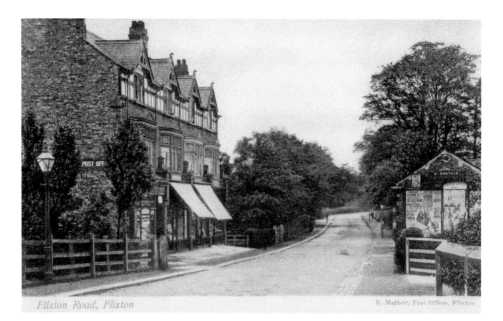

Flixton Road, Flixton R. Mather, Post Office, Flixton

Station View & Millott's Barn, Flixton Road, 1905 & 1904

Station View, on the left of Flixton Road, stood opposite Millott's Barn. The block was later expanded from four to six units by the 1920s. The 1911 Slater's Directory shows the post office standing opposite Williams Deacon's Bank, Walton Brothers grocery store and Johnson's confectioners, which was also the GPO public call office. The Tithe Barn was built around 1781, named after its owner in 1823, William Millott, and partially demolished around 1950. It had served as both village post office and shops. The remaining building after demolition was not the barn but the old administration house, which was converted into retail premises. Millott's Barn was a part of Millott's Farm, which consisted of 15 acres and belonged to the Ralph Wright Estate. The building to the left, on the 1905/04 postcards, is now a fast food enterprise.

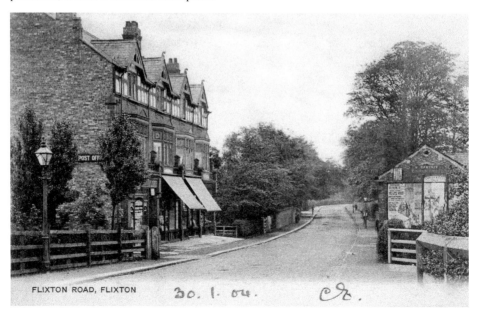

FLIXTON ROAD, FLIXTON 30. 1. 04.

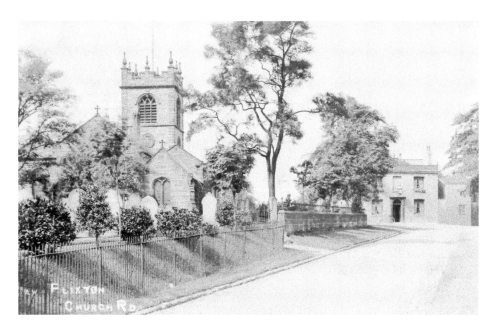

St Michael's Parish Church & the Church Inn, Church Road, 1906, & St Michael's *c.* 1910

Founded around 1190, St Michael's is a Georgian building of local sandstone. The postcards above and below show us the graveyard, which was enlarged in 1868 and 1887, fronted by Church Road, now used for parking after the demolition work of the early 1960s. The church tower, also shown, has been rebuilt twice. In 1729/31 it cost £300, but by 1863 it was again becoming unsafe and was rebuilt in 1889, in the same style but stronger and slightly higher. The two tower plaques commemorate rebuilding in 1888/89 and Queen Victoria's Jubilee. The oldest gravestone in the graveyard is marked 'WD 1669' and the largest belongs to the Walkden family. The church became Grade II listed in 1966. The colour postcard of the church (below) is taken from the 'Multi-view' image postcards shown elsewhere in this volume.

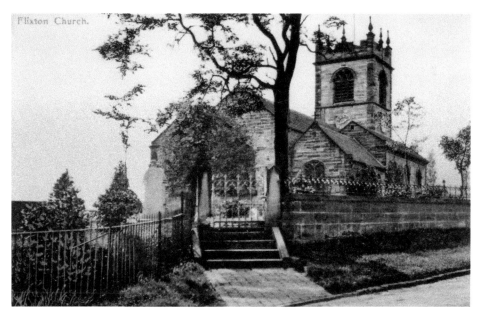

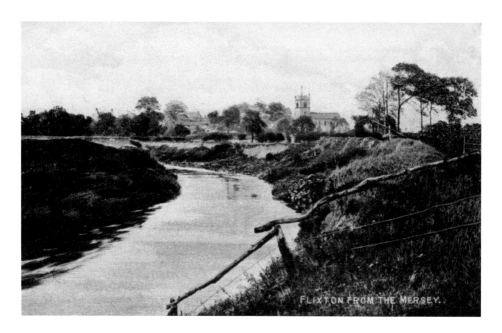

Flixton Village & St Michael's Parish Church from the River Mersey at Shaw Hey, 1907 & 1908

The colour image postcard really brings out the detail of this scene. At Shaw Hey a culvert diverted floodwater under Church Road at Shey Bridge and onto fields nearby. The raised and reinforced riverbanks shown here testify to previous attempts at flood defence, as does the name of the river 'Mersey', which is Anglo-Saxon for 'boundary'. This name is also particularly relevant to the Anglo-Saxons, in that the Mersey formed the border between the kingdoms of Northumbria and Mercia. The clock inside the church tower is weight driven, which also operated the bells. The clock, winding mechanism and dials were restored in 1990. The registers have been kept at St Michael's since 1570. Names prominent then were Radcliffe, Asshawe and Egerton. By the late nineteenth century Gratrix, Gilbody, Valentine, Millott and Low were prevalent.

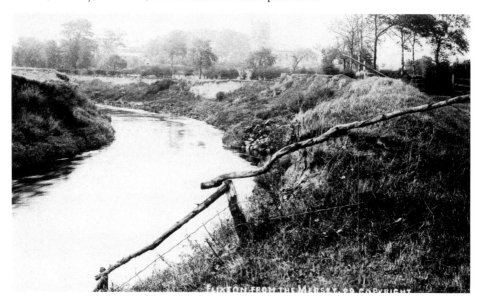

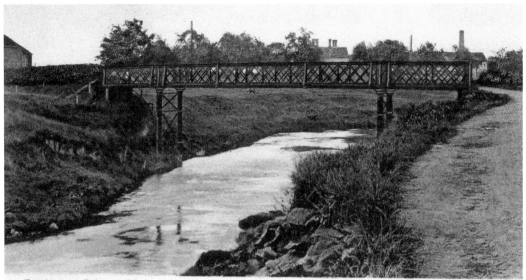

Carrington Bridge, Flixton

E. Mather, Post Office, Flixton

Carrington Bridge, Carrington Hall Farm & the Site of Flixton Bridge, Morris Grove, pre-1907
The site of Carrington Bridge at Morris Grove (shown below) is also known as Flixton Mile
Road (although it is less than a mile) or County Bridge. The wooden footbridge of around
1558/1603 was replaced by an iron footbridge around 1840, located where Carrington Road led
west from Mersey View, or Four Lane Ends, across the Flixton Eas. The road continued along
the banks of the river, crossing the Mersey close to Carrington Hall Farm (above) and allowing
the residents of Carrington to attend St Michael's church services. The new bridge crossed
land known as Treeley, owned by members of the Royle family, who also owned several other
properties along Carrington Road. The new bridge was built by M. Hanley of Hull. Delays were
caused by flooding, planning refusals and a compulsory purchase order.

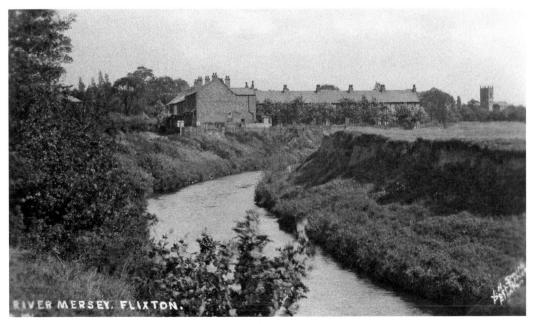

RIVER MERSEY, FLIXTON.

13

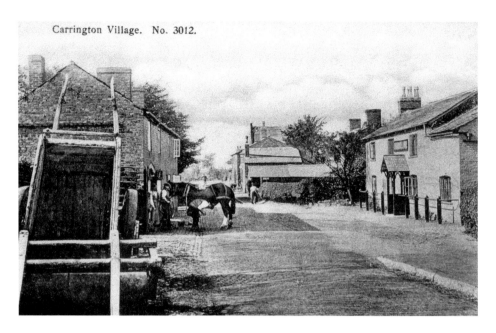

Carrington Village. No. 3012.

Carrington Village, Manchester Road & Carrington Lane, Ashton-on-Mersey, *c.* 1905
The postcard of Carrington village from Manchester Road (above) shows a very rural
scene, with the village blacksmith shoeing a horse. On the right the Windmill public house
is still here, but Manchester Road has been widened. St George's Chapel on the far right
also remains but has now closed. The postcard of Carrington Lane (below) looks towards
Carrington from near Ashton-on-Mersey. Today this busy road links the M60 to the M6
motorway at Lymm and has an extension to the M60 motorway known as the Carrington
Spur. Unfortunately, in 1986 the site of Hillam Farm and its outbuildings was destroyed
during the construction work for this extension. This left only its orchards intact, but a
further widening scheme of 2003 (opening 2006) meant that even these were entirely
removed leaving no visible trace.

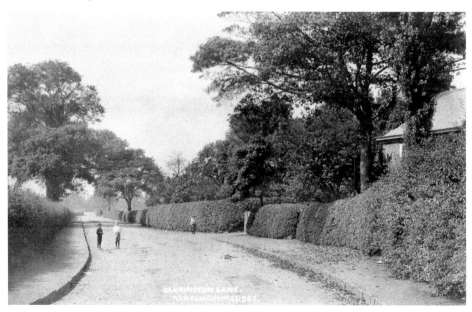

Partington Carnival *c.* 1925 & Partington Coal Basin, Manchester Ship Canal, 1905

A large paper mill was built here 250 years ago, making it the first factory in Trafford. In 1831 there was a 'mill board manufactory', a large corn mill and two tan yards to accompany the paper mill. The completion of the Manchester Ship Canal in 1894 transformed Partington into a coal exporting port (below) and attracted other industries like steel making, on the opposite canal bank at Irlam. Shortly after the Second World War part of Partington became an 'overspill estate', rehousing people away from slum and bomb clearance areas of inner-city Manchester. This transformed the previously rural outlook of the village (above). Partington was originally a township in the Parish of Bowdon, Hundred of Bucklow and County Palatine of Chester. Since 1974 it has been a part of the Metropolitan Borough of Trafford.

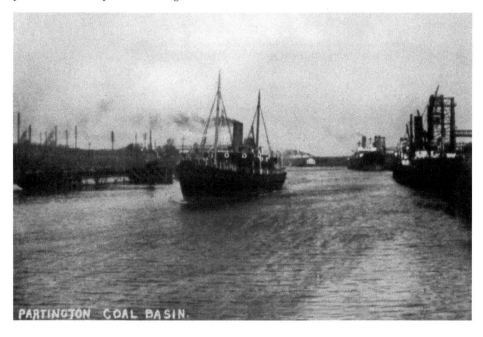

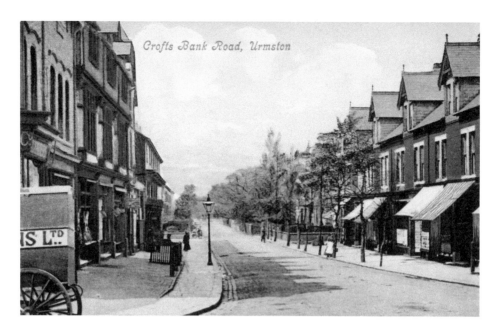

Crofts Bank Road, Urmston

Crofts Bank Road, 1905, & Peace Celebrations, Station Road Bridge, Urmston, July 1919
On the left (above) was Cuthbert's Butchers, which retailed here from 1903 to 2005 and then became part of the NatWest bank. Further along on this side was Silcock's Greengrocers, previously The Creamery, which retailed here from 1929 to 1999 and was later a florist and then a furniture store. On the right, at Crofts Bank Road's junction with Primrose Avenue, is the former Alliston Surgery, now a restaurant. This was once the practice of Doctors Graham and Wolstenholme. The practice was originally founded by Doctor Wolstenholme's father, Doctor Thomas Blakeway Wolstenholme OBE (Colonel), in 1903. He served in France during the First World War, was linked to the Territorial Army, was awarded the Croix de Guerre in 1918, and died in 1934. The terrace opposite became the old council offices in around 1964/65 and is now a Sainsbury's supermarket and a part of Eden Square.

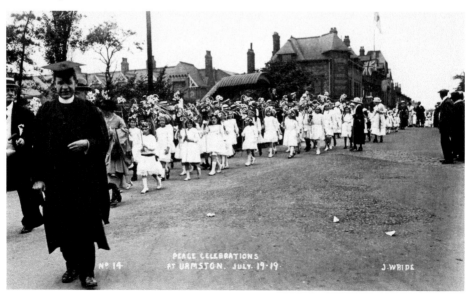

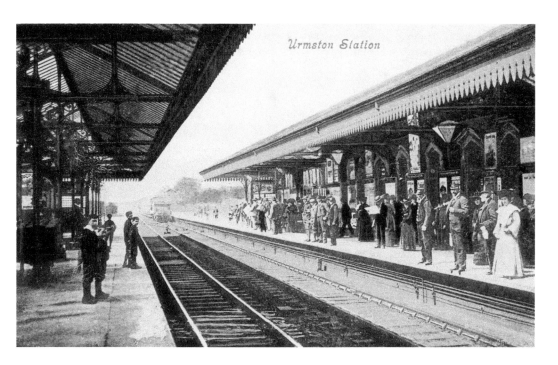

Urmston Railway Station *c.* 1910, & from Station Road Bridge *c.* 1900
The Duke of York public house was demolished for the station site. The platform canopies, shown in the colour postcard of around 1910 (above), were constructed in 1889, with the waiting rooms and booking office (also shown) demolished and replaced with new buildings around 1990. The coal yard and sidings, once occupied by coal merchants, a cab hire company and a building merchant, have also been removed, to be replaced by modern housing and car-parking facilities. Opened by the Cheshire Lines Railway on 2 September 1873, the original station buildings were Gothic in style (see below). In 1889, a new booking office on Railway Road was constructed, and a ladies' waiting room erected. The station footbridge was demolished in 1927 when the road bridge was widened, and the platform canopies were removed in 1965.

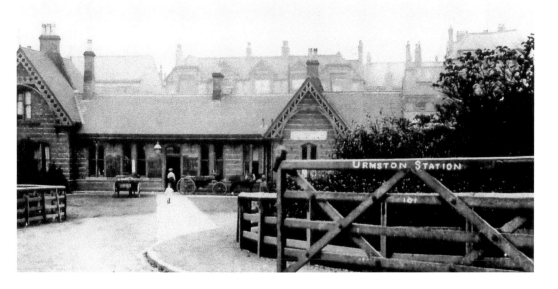

Station Road Junction with Church Road *c.* 1904 & looking towards Crofts Bank Road, 1903
The former Temperance Billiard Hall, to the right of the postcard above, was built in 1909, providing entertainment without the temptation of alcohol. After the Second World War it had a short spell as a roller-skating rink until it was taken over by Vernon's and became a supermarket. It came up for sale in 1956 and was occupied by Terry's store. In recent years it became a restaurant and was then put up for sale, becoming a restaurant again! The building is opposite the old police station of 1904, now commercially developed. Station Road (below) takes its name from the railway station at the road bridge junction with Crofts Bank Road. The Cheshire Lines Railway was formed around 1872, dividing the urban district. The line connected the cities of Manchester and Liverpool, and locally led to the foundation of Urmston Market.

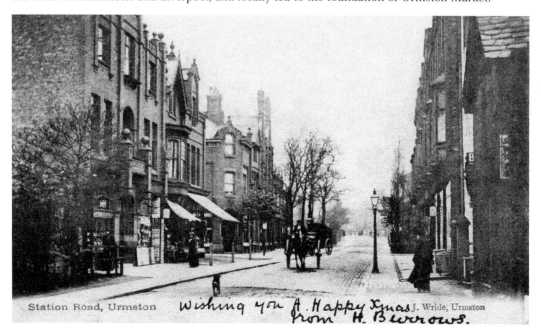

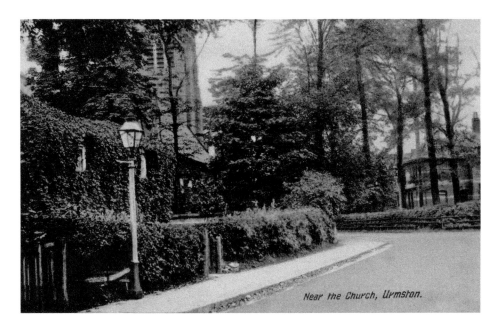

'Near the Church', Stretford Road, Urmston, 1910 & c. 1905

The cottage on the left (above and below), built around 1830, is now the location of St Clement's Vicarage. Its neighbour was the residence of George Spark, a local builder. Spark's Builders had signs in situ at this spot advertising their services, which included the construction of the Cottage Hospital, on Greenfield Road, and English Martyrs Roman Catholic Church, on Roseneath Road. These signs are just off camera in both the postcard images of Stretford Road. Spark & Sons were located on Higher Road. The company began as a timber mill in 1880, under the name of Joseph Spark. They later became a timber merchant and contractor, with sons George, Joseph and Donald successively running the business. The yard was originally next to Greenfield Farm, at the corner of Station Road, moving to Higher Road in 1928.

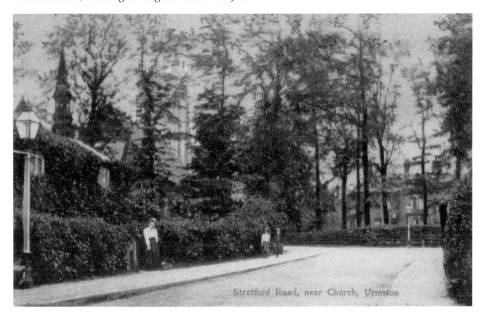

19

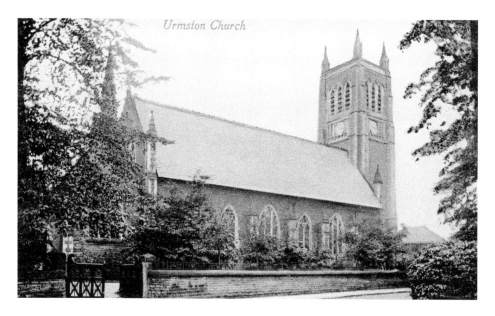

Urmston Church

St Clement's Church, Stretford Road, Urmston, 1910, & Church Tower under Construction, 1903

The church (above) was founded in 1867 on land donated by Colonel Ridehalgh and restored in 1874/75 and 1888. It was designed by James Medland Taylor and built by Mark Foggett at a cost of £2,125. Yorkshire stone in three colours and a slate roof were used in its construction, which was in the geometrically decorated Gothic style. The Rector of Flixton, Revd Charles Barton, named the church. The foundation stone was laid on 16 March 1867 and was blessed by the Archbishop of Manchester, Doctor J. Prince Lee, who also consecrated the finished church in January 1868. It became Grade II listed in 1987. In 1894, the organ chamber was donated by the Sparrow family of Urmston Lodge, with the clock being provided by the Reade family of the Manor. One bell was installed in the newly constructed church tower (below) in 1906.

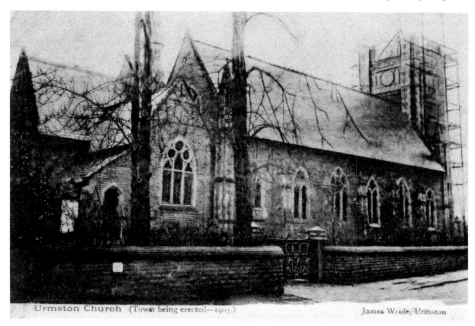

Urmston Church (Tower being erected—1903.) James Wride, Urmston

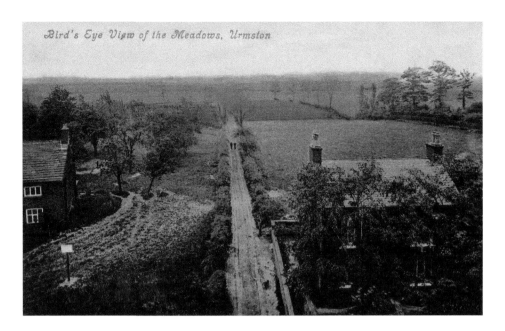

'Bird's Eye View of the Meadows, Urmston' from the Roof of the Lord Nelson Hotel, 1907 & 1905

Trafalgar House (above and below right), built around 1820, stands directly opposite the Lord Nelson Hotel at the junction of Stretford Road and Meadow Road, where it is said there was once a rifle range. The lane led to Cob Kiln Woods, where there was a brick kiln – giving the lane its name. Meadow Road only became known by this title sometime after 1910. The hotel opened in 1805. Built by George Royle, it comprised 15 acres of farmland and outbuildings. It was rebuilt in 1877 by George Royle's grandson and was used when the local courts were in session. It was also a terminus for local horse-drawn tram and bus services. In the Victorian/Edwardian era there was a smithy next to the hotel, now a garage. Bear baiting, abolished in 1835, was once held on its courtyard.

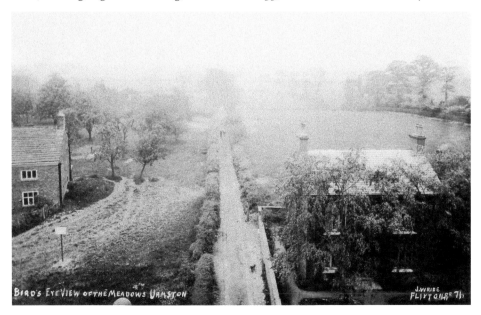

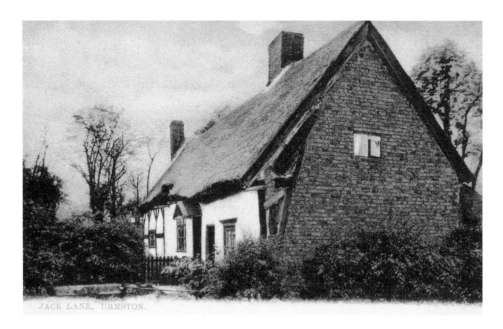

JACK LANE, URMSTON.

Old Cottages in Jack Lane & Ciss Lane, Urmston, 1906

During the early nineteenth century the occupant of Jack Lane Cottage (above) used to leave his front door open so schoolchildren could see the clock and not be late for school. These two old lanes were first recorded at this time, with the site being the location of traditional thatched cottages. At the corner of Higher Lane and Ciss Lane (below) one of the cottages was dated 1870 and survived into the twentieth century. A similar cottage, on Jack Lane, was demolished around 1935. The two lanes remain, with Jack Lane and neighbouring Ciss Lane redeveloped, but not renamed. The last cottage was demolished at Jack Lane's junction with Higher Road. At its junction with Stretford Road was the White Lion Inn and later Bailey's Mill, established in 1923 but now gone.

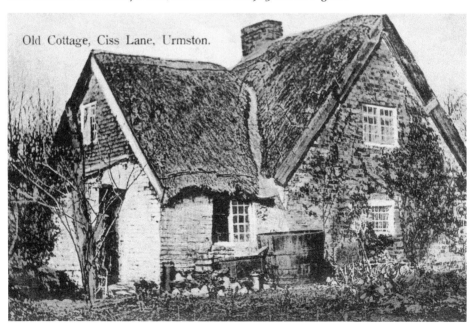

Old Cottage, Ciss Lane, Urmston.

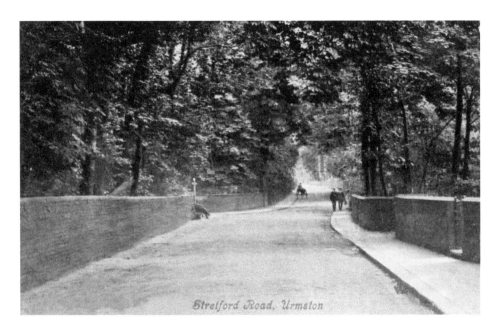

Stretford Road at Its Junction with Moss (Vale) Road, Urmston, *c.* 1910

Stretford Road (above and below) underwent much suburban growth, from a country lane and haunt of the 'Gamershaw Boggart', to the place where the M60 motorway bridge crosses today. Close to the motorway crossing at Stretford Road is the Moss Vale road bridge over the Manchester/Liverpool railway line. Here, in December 1958, the express train from Liverpool to Central Station collided with a fallen crane working on a new road bridge. A second train then struck the crane from the opposite direction. One died and thirty-nine were injured. Stretford Road (Urmston Lane in Stretford) is today a main route between the town centres of Urmston and Stretford. In the days of the horse-drawn omnibus it provided an invaluable link for commuters between Urmston and Stretford railway stations.

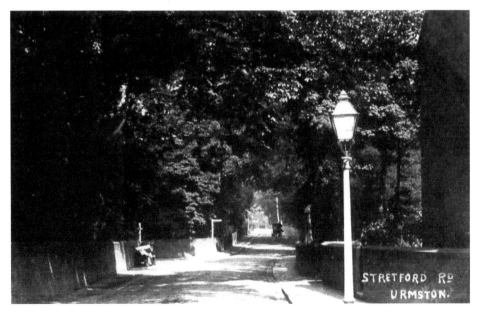

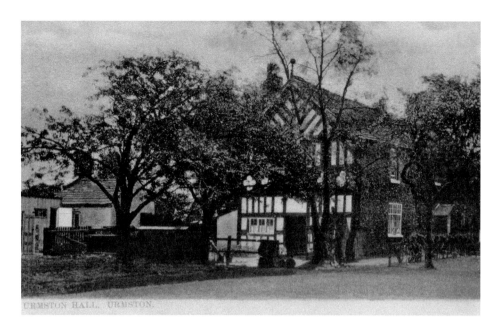

Urmston 'Old' Hall, Manor Avenue, Urmston, 1905

Built in 1580 and demolished in 1937, despite efforts to save it by the Manchester Town Planning Committee, Urmston Old Hall was a gabled, timber and plaster Tudor building, decorated in lozenges and trefoils. Its side elevations were brick, and a date of 1731 on the north side suggests later renovations, with the initials 'IHE'. Both postcards illustrate this original detail. Mentioned in William Hyde's will of 23 August 1587 and later owned by the Egerton's, in 1874 the hall was owned by Cecil de Trafford and tenanted by Jonathan J. Stott, a farmer of 80 acres by 1880. By 1901 it was a farmhouse belonging to the Ridehalgh family and still tenanted by (presumably the same) Jonathan Stott. Ormeston Lodge was built on the site of Urmston Old Hall, off Queens Road, in 1984.

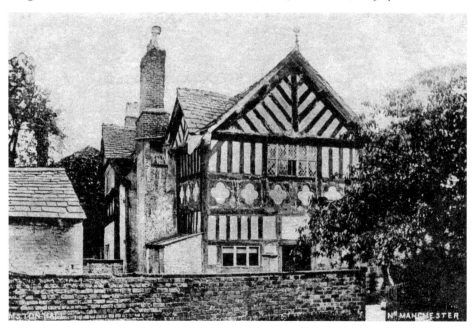

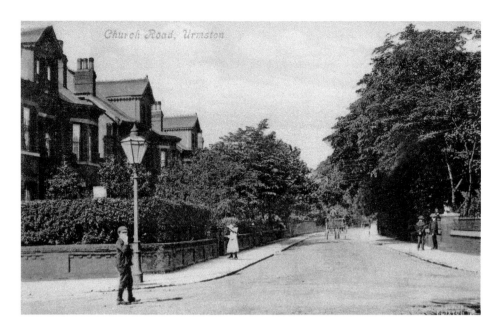

Church Road from Grange Road, Urmston, 1907 & 1903

Church Road was previously known as Church Lane, or Shaw Hall Lane. The road begins at Flixton Village and ends at its junction with Stretford Road, in Urmston. These postcards give us a view of Church Road from the corner of Grange Road, looking towards Moss Grove (Dartford Road) on the right. Here it is believed that Tim Bobbin's cottage once stood. Born in Urmston on 16 December 1708, the satirist and poet was baptised John Collier at Flixton on 6 January 1709. Church Road has changed extensively since, receiving utilities from 1881 and being sequentially widened from 1950/69, with many old cottages systematically demolished. One feature remains– the slip road alongside St Michael's parish church. This was once the main road through Flixton Village, past the Church Inn and in front of the village cottages.

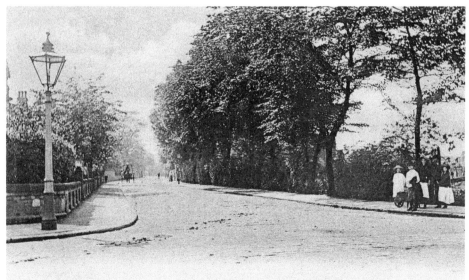

Church Road. URMSTON. *With Best Wishes for Xmas and The New Year.*

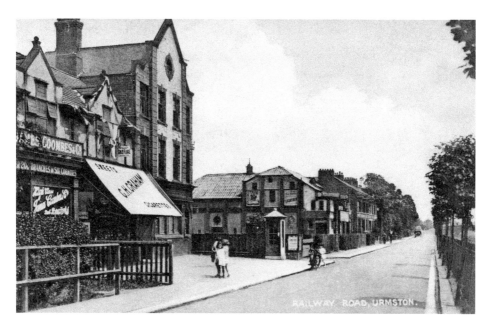

Railway Road & the Palace Cinema, 1936, & Westbourne Park Gates, 1912

The terrace on the left (above) was previously occupied by the Gardener's Institute and Allotment Society, the telegraph and telephone exchange, and a shoemaker. Next to the confectioners is the post office and beyond Urmston Market the town's first purpose-built cinema, Urmston Picture Palace, opened in 1912 and closed in June 1957. After Urmston Council tried and failed to buy it, a factory occupied the building. Flats are now located here. Urmston Rifle Club was established at Westbourne Park (below) in 1889, with a miniature rifle range bordering Oak Grove. It was said to be the first 'small bore' rifle club in the country. At its entrance stood a gateway, sided by two towers (left), removed in 1950. The club closed in the 1960s and much of its land is now allotments. Colonel Cody (Buffalo Bill) became a patron of the club in 1903.

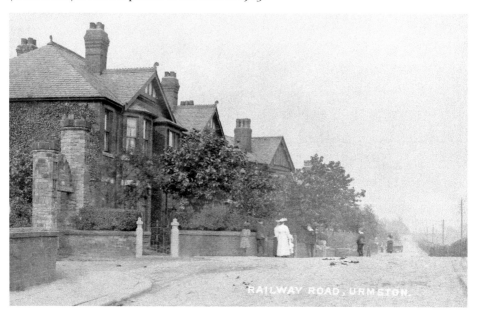

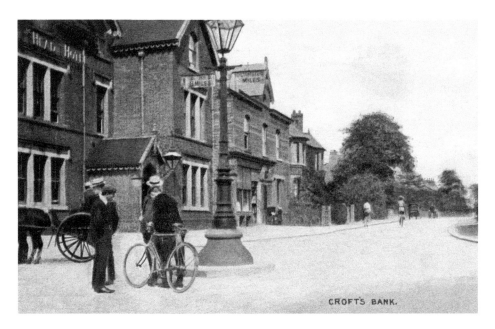

The Nag's Head Hotel, Crofts Bank & Lostock Road, 1905, & Cenotaph *c.* 1930
Modern housing along Lostock Road first appeared in 1929, with the road and cycle tracks constructed in 1936. In 1905 (above) the Nag's Head Hotel, Faulkener's grocery store, Bella Vista, Glenluce and the Lindens (behind the trees) were located along Lostock Road. The Lindens was built in 1890, with Robert Estill and family moving there around 1901. Today the same row consists of the Nag's Head Hotel, and sequentially over many years an Italian restaurant, a dental surgery, a retail development, petrol station, and an office block, formerly Lostock Hall Residential Hotel. The public house (above and below) dates from the sixteenth century and was originally the size of a small cottage. It was demolished around 1870. There was a bowling green to the rear, constructed around 1895, destroyed by a bomb around 1940 and now developed for residential purposes.

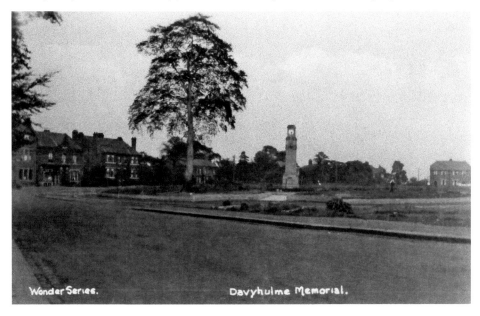

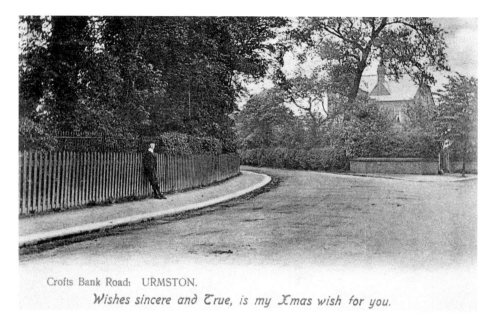

Crofts Bank Road: URMSTON.

Wishes sincere and True, is my Xmas wish for you.

Haylands, Crofts Bank Road & Old Crofts Bank Junction, 1903, & 'Multi-view' of Davyhulme, 1937

The Victorian mansion of around 1870 shown in the 1903 postcard above is called 'Haylands', which is now 'a residential home for gentlemen'. The left-hand corner of this junction once belonged to 'Woodlands' around 1890, later Urmston Social Club, formed in 1973 and now demolished. The dedication to 'Xmas' is a nice touch. The 'Multi-view' images below show Park Hospital, Crofts Bank Park and Urmston Baths. The top right image shows 'Haylands' as the central property, beyond Crofts Bank Park, on Talbot Road as it was briefly known at this time. The nearby Nag's Head circle is dominated by the Cenotaph, dedicated to the memory of those who lost their lives in two world wars. Constructed of Stancliffe stone, the Cenotaph was officially opened in 1929 by J. P. Forsyth, the chair of Davyhulme Council.

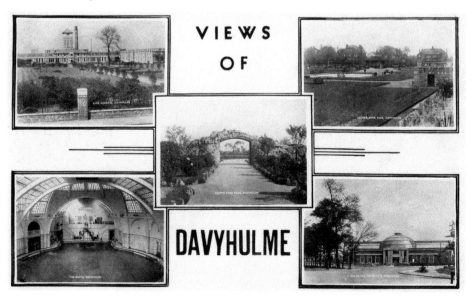

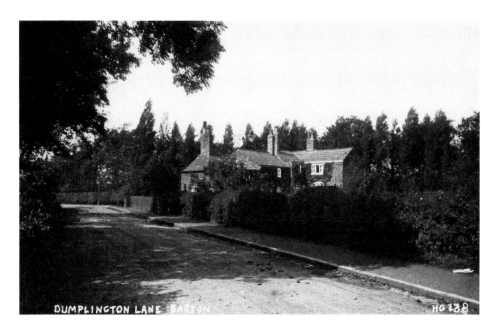

Dumplington Lane, Barton, 1915, & St Catherine's Parish Church, Barton, *c.* 1900

Today Dumplington, between the Nag's Head and Barton Bridge, is known as Ellesmere Circle and Trafford Boulevard. In 1890 the area was known as Wilderspool Woods, with Redclyffe Road known as Dumplington Lane (above). The first record of a house here was in 1781, when it was a private residence known as Wilderspool Hall, with a farm south of it. The property was demolished in 1963, with the land being used for farming. The farm was removed in 1967/68 and is now the site of a Travel Inn. St Catherine's Church (below) served the Church of England parish of Barton-upon-Irwell and was next to All Saints Roman Catholic Church. The land for St Catherine's was donated by Sir Thomas de Trafford. The foundation stone was laid by Lady de Trafford on 22 July 1842, and it was consecrated on 25 October 1843. Today only the vandalised graveyard remains.

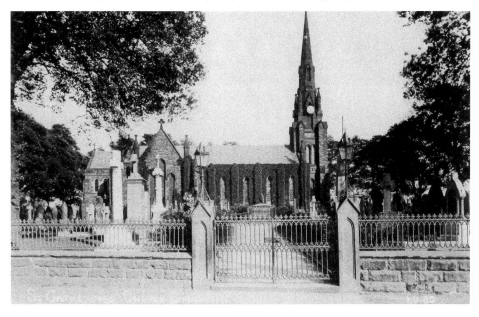

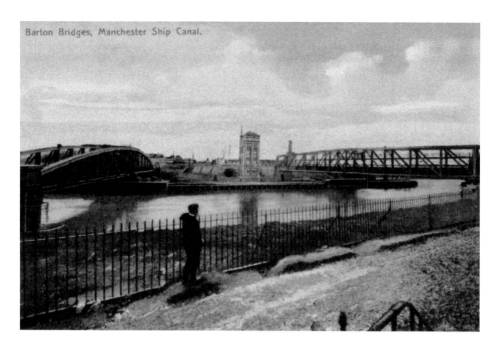

Barton Swing Bridge & Aqueduct, Manchester Ship Canal, 1909, & Swing Bridge *c.* 1900
Constructed around 1893, the whole complex of bridge, aqueduct and control tower was
Grade II listed in 1987. The engineer was Sir Edward Leader Williams (1828–1910) with
Andrew Handyside & Co. providing the materials. The Swing Bridge, on the colour postcard
(above left), weighs 800 tons, is 195 feet long and 25 feet wide. It is taken from the Barton
side of the canal, whilst the postcard below is taken from the Eccles side and shows
All Saints Roman Catholic Church beyond. There had been long-standing discussions
regarding the construction of another canal crossing beginning in 1928, as Barton was
believed to be something of a traffic bottleneck. One proposal was the construction of a
tunnel, which was refused as it would have cost £720,000 more than the building of a bridge.

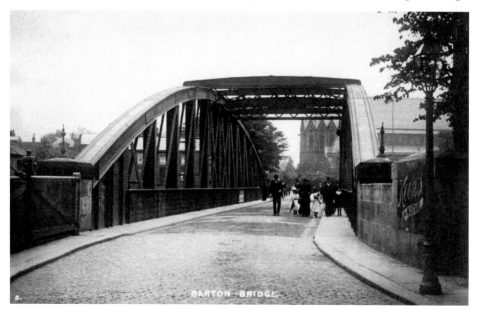

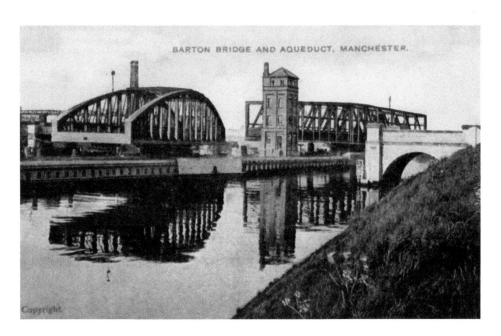

Barton Swing Bridge & Aqueduct, Manchester Ship Canal, *c.* 1905, & Aqueduct, 1914
The Aqueduct, above right on the colour postcard and below, is 235 feet long and weighs
450 tons, swinging on a central axis to allow the passage of ships along the Manchester
Ship Canal. The water channel remains full when turning. James Brindley (1716–72)
designed the Bridgewater Canal, his stone aqueduct being built around 1761 and replaced
around 1891. There are remains of this aqueduct preserved on the Eccles side of the
Manchester Ship Canal and marked by a plaque. It was to be 1960 before an alternative
to these crossings was constructed, with the opening of the M62 (M60) motorway high
level bridge by Sir Arthur Smith in March 1961. A suggestion to convert the existing Irlam
railway bridge into an alternative canal crossing proved unsatisfactory, both in terms of
cost and suitability.

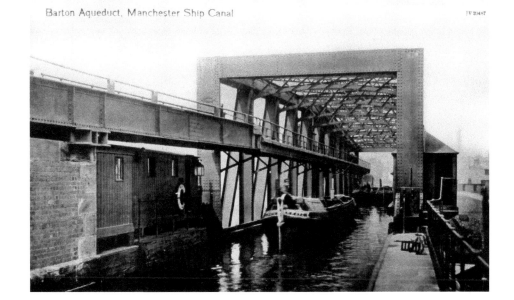

Barton Aqueduct, Manchester Ship Canal

CHAPTER 2
STRETFORD
AND OLD TRAFFORD

FLOODS AT SUNSET, STRETFORD.

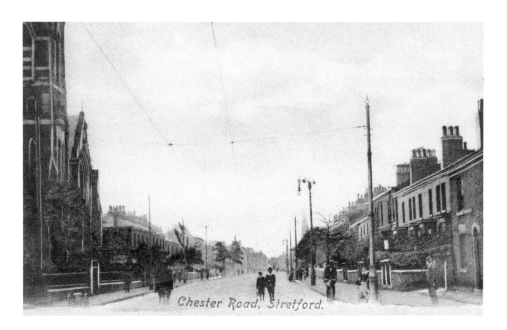

Chester Road, Stretford, 1908 & 1909

St Ann's (above left) was designed and built in 1862–67 by Edward Welby Pugin (1834–75) for Sir Humphrey and Lady Annette de Trafford. Pugin also designed and built All Saints Roman Catholic Church (1867–68) at Barton for the de Trafford family. St Ann's was officially opened by Bishop William Turner on 22 November 1863, and was consecrated on 18 June 1867. Features include a historic organ built by F. W. Jardine & Co., 1867, and stained-glass windows by Hardman & Co. of Birmingham. Chester Road, 1909 (below), shows tramlines looking towards Sale. On the right is Stretford Public Hall and Chester Road's junction with King Street. Edge Lane's junction with Chester Road is on the left. In 1936 the Longford (Essoldo) Cinema opened here, quickly becoming a local landmark, and by the late 1960s Chester Road had been redesigned at this junction.

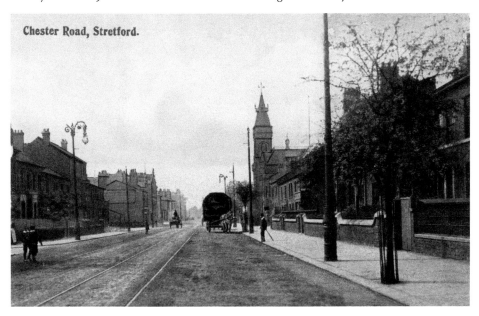

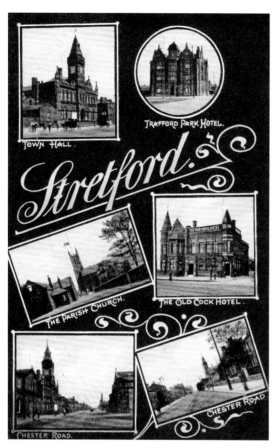

Stretford 'Multi-view', 1906, & the Talbot Hotel & Stretford Town Hall, Chester Road, 1898

Sir Humphrey de Trafford, Baronet and the twenty-eighth Lord of the Manor of Stretford, married Mary Annette Talbot, sister of the Earl of Shrewsbury, on 17 January 1855. The Talbot Hotel (below) and the Shrewsbury Hotel, at Old Trafford, were named after the family. The first licensee of the Bishop Blaize Inn (demolished in 1863 for the Talbot Hotel) was Thomas Siddall, with famous visitors including James Brindley, engineer of the Bridgewater Canal. In March 1949 the Public Hall (above left and formerly the town hall) reopened as the Stretford Civic Theatre. It became Grade II listed in 1987 and began to fall into rapid decline, until Trafford Council refurbished the building for use as council offices, reopening in 1997. The public baths were once located on Cyprus Street, behind the Public Hall.

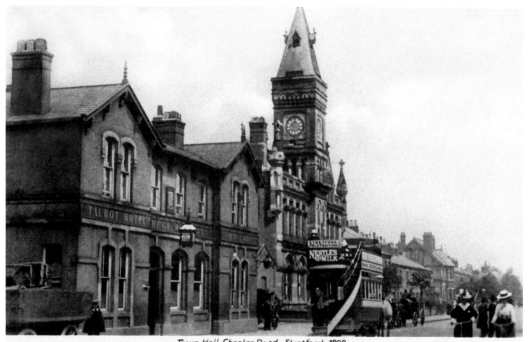

Town Hall Chester Road Stretford 1898

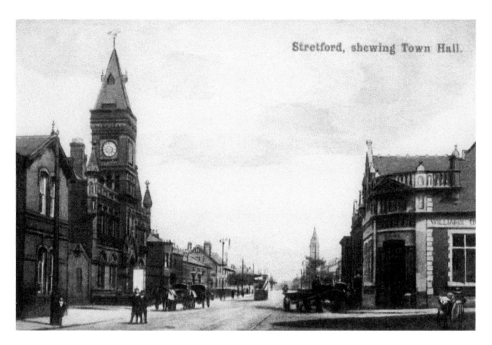

Stretford Town Hall, Junction of King Street & Chester Road, *c.* 1910, & Urmston Lane, 1910
The first town hall of 1879 was originally the Public Hall and public library, which was given to the town by John Rylands. It was later used for other services to the community, when a new Stretford town hall (now Trafford town hall) was opened. It is built in the Gothic Revival style. The doorway has a moulded arch which rises from a tower that has a balcony and a cast-iron parapet. The tower also has striking clock faces, a frieze and a steep pyramidal roof. There are parapets and corner pinnacles at the top of the building. The postcard above looks towards Manchester along Chester Road and shows the Talbot Hotel and the town hall on the left. Williams & Glynn's Bank can be seen on the right. Urmston Lane (below) looks towards the town centre.

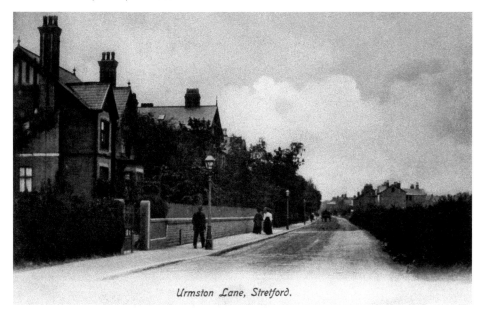

Urmston Lane, Stretford.

Barton Road, Stretford.

Barton Road, 1911, & Cottages & Pinfold, Junction of Barton Road & Urmston Lane, 1896
On the right of Barton Road in 1911 (above) is the Independent Methodist Chapel, now the Trafford Christian Life Centre. However, the most striking change in this view is the construction of the tower block Stretford House, which was opened in 1968 and now dominates this part of Stretford. Today, Barton Road is a very busy link route for traffic heading towards the M60 or Trafford Park and has attracted some controversy in recent years due to the number of heavy lorries using it. The Pinfold was once located at the junction of Urmston Lane and Barton Road (below) and was an enclosure where stray animals were confined. The term is Saxon in origin. A fine or levy was ordered for the return of livestock to their owners. This covered damage to land and animal care.

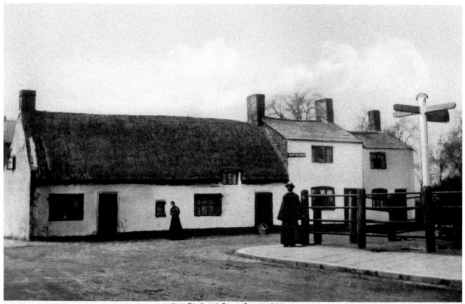

" The Pinfold", Stretford -1896.

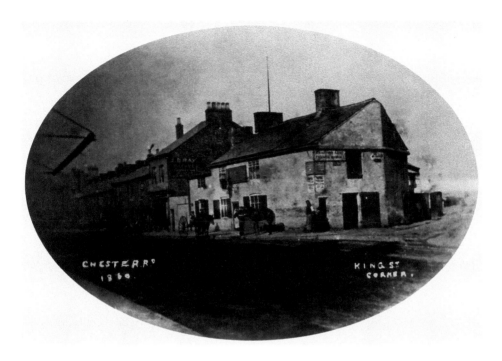

Trafford Arms, Junction of Chester Road & King Street, 1860, & King Street *c.* 1930
According to the painted board on the end gable of the building (above) the proprietor of the Trafford Arms in 1860 was Francis Worrall. The junction of Chester Road and King Street was formerly known as 'The Cross', from the time when an old cross stood in the village here. In the postcard of the same junction around 1930 (below) we can see the Picturedrome Cinema (1911–61) next to King Street post office, on the right. There is a former cross base in St Matthew's Church graveyard, which was later used as a sundial base and is believed to be of medieval origin. One side has been refaced and inscribed in 1863 to commemorate its removal from the junction of Chester Road and King Street, informing us that it is the 'remains of the Stretford Cross'.

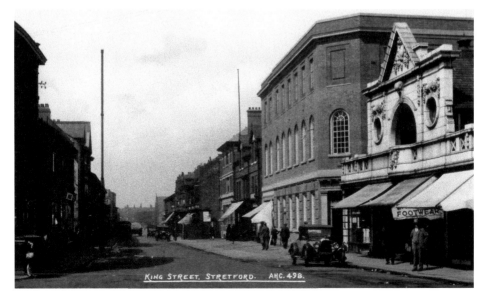

Old Cock Hotel, Chester Road, Stretford, looking towards Manchester, 1907, & Sale, 1870
Situated at the junction of Chester Road and Higgin Lane (Barton Road) the Old Cock
(above left and below) was one of the area's oldest inns. It was the terminus and
starting point for omnibus services beginning in 1845, and later the horse tramways, the
Manchester Carriage Company's tramway being built in 1879. A small depot was also
built next to the inn, housing cars and horses. The Victorian Old Cock Hotel replaced the
inn around 1880 and it is today used as commercial premises. The view looking towards
Chester Road's junction with Barton Road (above) and Manchester is now dominated by
the site of the twenty-three-storey Stretford House. It was officially opened by the Mayor,
Cllr Mrs A. Kirkbright, in 1968, for Stretford Corporation. In 1907 there were cottages
located here as well as Vine Farm, also known as Kelsall's Farm.

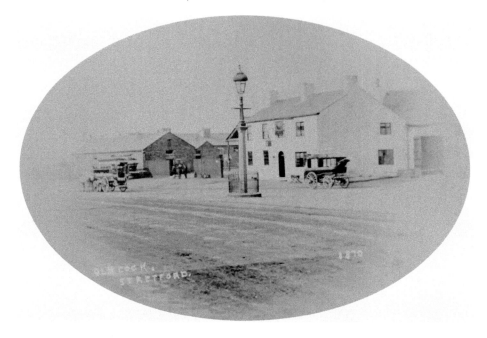

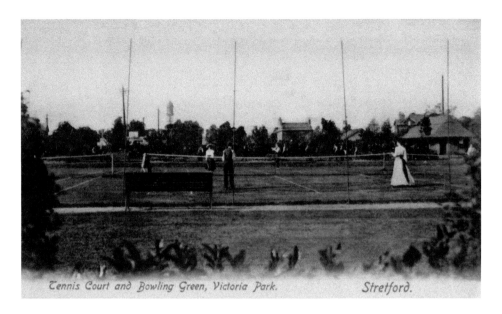

Tennis Court and Bowling Green, Victoria Park. *Stretford.*

Victoria Park, Victoria Road, Stretford, 1909, & Hullard Park, Northumberland Road, Old Trafford *c.* 1900

The entrance gateposts to the park read 'Stretford Urban District Council: These Gates were Presented to the Township of Stretford By John Slyman JP.CC. November 15th 1902;' (left) and 'To Perpetuate, The Memory, And Beneficent Reign of Her Most Gracious Majesty Queen Victoria. Born 1819. Acceded, To, The Throne 1837. Died 1901. "The Throne is Established by Righteousness." PROV. 16.12.' (right). John Slyman (1844–1912) was a cotton merchant who resided at Thorncliffe, Urmston Lane, Stretford. The view of Victoria Park's tennis courts and bowling green in 1909 (above) give us a good idea of how the middle classes entertained themselves in Edwardian times. In the background can be seen the water tower of the Westinghouse Engineering Works, which supplied water to the factory in Trafford Park. Hullard Park (below) displays flower beds.

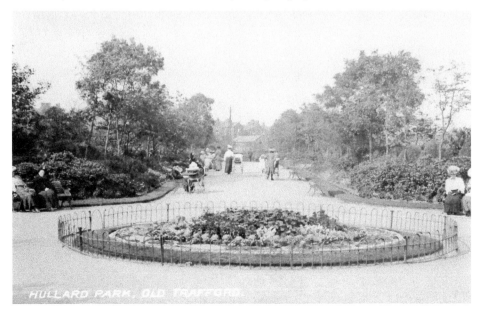

HULLARD PARK, OLD TRAFFORD.

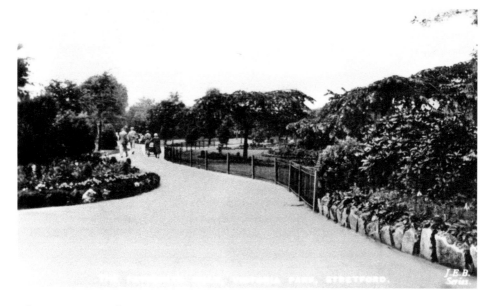

'The Favourite Walk', Victoria Park, Victoria Road, Stretford *c*. 1905, & the Bowling Green, 1908

Elsewhere a plaque reads 'To Perpetuate, The Memory, And Beneficent Reign of His Most Gracious Majesty King Edward VII. "The Peace-Maker." Born 1841. Acceded, To, The Throne 1901. Died 1910.' John Slyman again presented these gates, this time in 'AD 1910'. In 1897 he was chairman of the Queen's Diamond Jubilee Committee (Stretford). One third of the £1,800 raised was used towards opening Victoria Park in 1902, and two thirds helped to furnish and equip the Technical Institute and Free Library at Old Trafford. Another postcard view of Victoria Park in colour (above) shows the vibrant colours of summertime in this part of Stretford. Below is another view of the bowling green. There is a handwritten address at the top of the postcard of '83 Wingfield St, Gorse Hill, Stretford, N/r Manchester'.

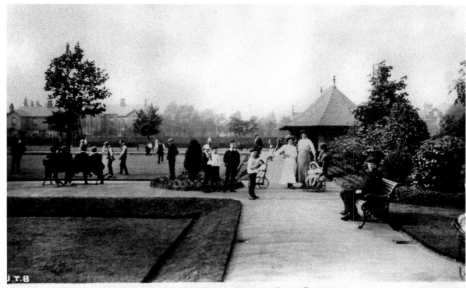

Corner of Bowling Green, Victoria Park, Stretford

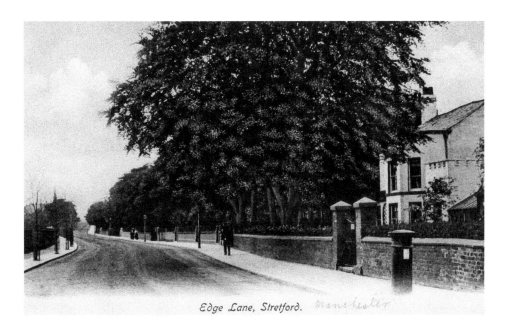

Edge Lane, Stretford. *Manchester*

Edge Lane towards the Wesleyan Chapel *c.* 1910, & towards Chorlton-cum-Hardy, 1909
Looking towards Stretford (above) the Edge Lane canal bridge was once the site of a wharf, used to land large numbers of pigs exported from Ireland via Liverpool and the Bridgewater Canal. Edge Lane acted as a general boundary between Longford and Turn Moss and is a main route into Chorlton-cum-Hardy (below). Local legend has it that a boggart, 'The wagon with headless team and headless teamster', haunted Edge Lane to the township boundary posts with High Lane and Wilbraham Road. The above postcard looks towards the Wesleyan chapel on Edge Lane. Built in 1862 and registered for marriages on 13 August 1866, it had seating for around 500 and originally cost £3,000 to build. However, alterations and additions added a further £2,000. The architect was Henry Fuller of London, in the Modern Gothic style.

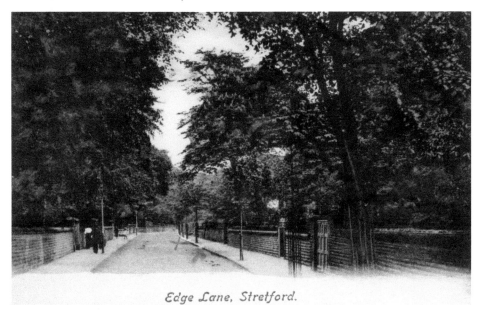

Edge Lane, Stretford.

41

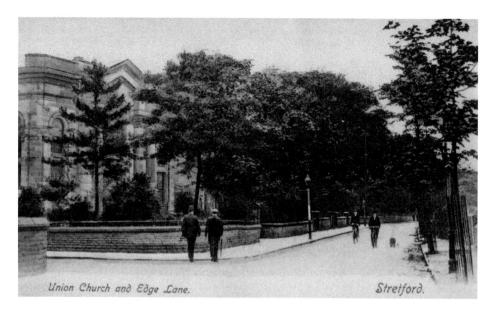

Union Church and Edge Lane. Stretford.

Union Baptist Church, Junction of Edge Lane & Kenwood Road, Stretford, 1907 & 1914
Edge Lane Union Baptist Church was formed in 1862 and was opened by John Rylands in
1867. According to Crofton it was registered for marriages on 10 June 1867. Rylands was
a Congregationalist, with leanings towards the Baptist faith, and supported several Union
chapels. The building was renamed Rylands Hall, the offices of the St Vincent Housing
Association and is now Iglesia Ni Cristo (Church of Christ). The Philippines-based
group use it as a place of worship, spiritual study centre, residential accommodation
and ancillary offices. The church became a Grade II listed building on 27 March 1981.
The style is 'Classical, in a Baroque vein', the chapel having additional rooms and vestries.
The interior fittings originally included timber pews, a gallery and pulpit, a coved ceiling
and stained glass. It is constructed in brick with a stone front.

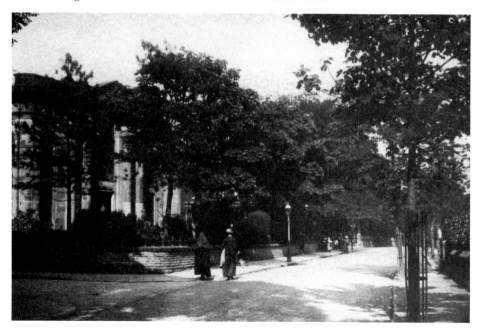

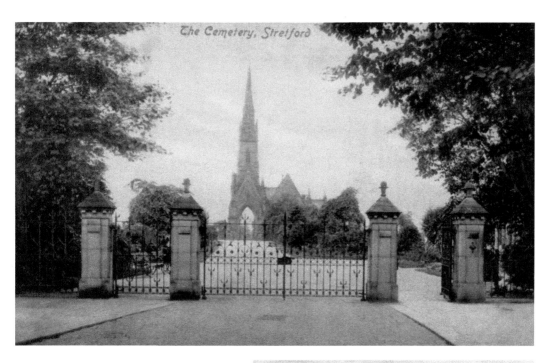

Stretford Cemetery, Chapel of
Rest & Gates, Lime Road, Stretford,
1912 & 1904

The entrance to Stretford Cemetery
is reached via Edge Lane's junction
with Lime Road. The cemetery
borders the Bridgewater Canal and
Metrolink tramline. It was designed
by John Shaw and opened on
4 February 1885. The chapel of rest
(shown in both postcards), whose
architects were Bellamy & Hardy,
is in the Decorated style and quite
elaborate. Although the chapel of
rest is still in situ, it is no longer
available for services. On the
western side is a memorial to the
casualties of the Second World War
and to the east is a newer section of
the cemetery. The postcard of 1912
(above) shows the chapel of rest and
cemetery gates from Lime Road,
whilst the postcard of 1904 (below)
again shows the chapel of rest, but
from the surrounding graveyard.

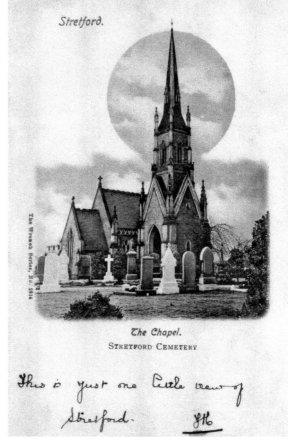

Stretford.

The Chapel.
STRETFORD CEMETERY

This is just one little view of
Stretford.

Old Trafford Essence Distillery, Manchester

where DUCKWORTH & CO'S Famous

HEART BRAND
ESSENCES & COLOURS
are manufactured and distributed to Aerated Water and Cordial Factories throughout the World, for the production of Beverages of Gold Medal Quality!

□ □
USE ONLY
"HEART BRAND"
ESSENCES & COLOURS
FIRST FOR QUALITY
STRENGTH & VALUE!

POST CARD.

STAMP.

Messrs. DUCKWORTH & CO.,

Old Trafford Essence Distillery,

Chester Road,

MANCHESTER,
ENGLAND.

Duckworth & Co., Essences Ltd, Chester Road, Old Trafford, Advertisement Postcards *c.* 1900

The Duckworth Company was founded in Manchester in 1885 by twenty-four-year-old William Duckworth. In 1896, the purpose-built Duckworth's Essence Distillery building (above) opened to a design by architects Briggs and Wolstenholme, with the office block shown fronting Chester Road at its junction with Northumberland Road. In 2003, the company was taken over by the food giant Cargill. Then, in October 2007, it was reported that the building had been purchased for £3.6 million by the Church of Scientology. The former factory building remains impressive, built in brick with terracotta detailing and roofs in Welsh slate and tile. It has an L-shaped plan and an almost symmetrical front of twelve bays. Towers flank the central bays and throughout the building there are columns and urns, parapets and pinnacles.

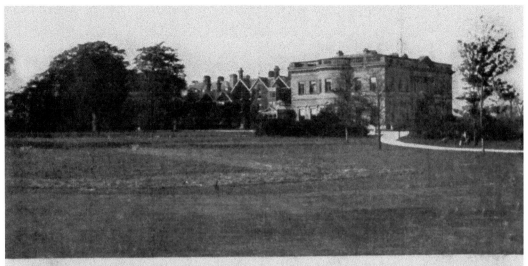

Trafford Park & Hall, Manchester.

Advertisement Postcard for Paulden's Dept. Store, showing Trafford Hall, Manchester, 1896
Once a rural estate, deer roamed freely around the grounds of Trafford Park and the hall (above) was surrounded by an ornamental garden with a glass conservatory and kitchen garden. The rear part of the hall was ivy-clad and dated from Elizabethan times. Inside, there were eight main reception rooms and a glass fernery. The main entrance hall was nearly 1,200 square feet in area. There were over forty bedrooms on the first floor, which also housed the de Trafford's private Catholic chapel. William Paulden began trading on Stretford Road in the 1860s, continuing until 1957. Their store, shown below, was built in 1879 and was refurbished in 1957. On the Sunday before it was due to reopen a fire broke out that completely gutted the building. It reopened on Market Street in 1959.

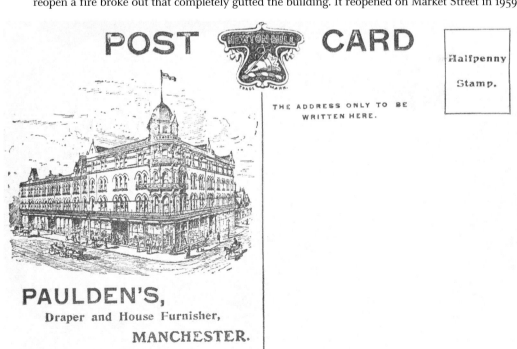

45

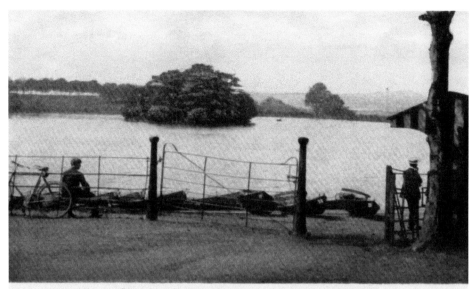

Boating Lake, Trafford Park, Manchester

Trafford Park Boating Lake, Trafford Park Road & Lake Road, 1906, & Trafford Road Swing Bridge, 1910

By the River Irwell, later the Manchester Ship Canal, was a large ornamental lake, now Trafford Ecology Park. This was populated by a colony of wild birds and had a wooded island in the centre. There was also sloping terrain, where bluebells and rhododendrons grew. The lake had an area of around 8 acres and was dug around 1860. A rustic boathouse on the western side of the lake was later replaced by a new one on the eastern side (shown above). The nearby Trafford Road Swing Bridge (below) was built to allow ships entry into Pomona Docks. It was Grade II listed in 1987 and was built around 1892 by John Butler & Co. using wrought-iron lattice girders. It is the largest and the widest of the Manchester Ship Canal's seven bridges.

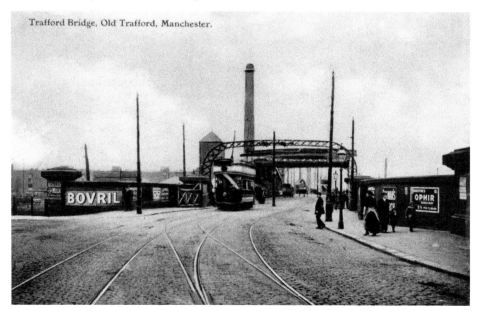

Trafford Bridge, Old Trafford, Manchester.

CHAPTER 3
ASHTON-ON-MERSEY

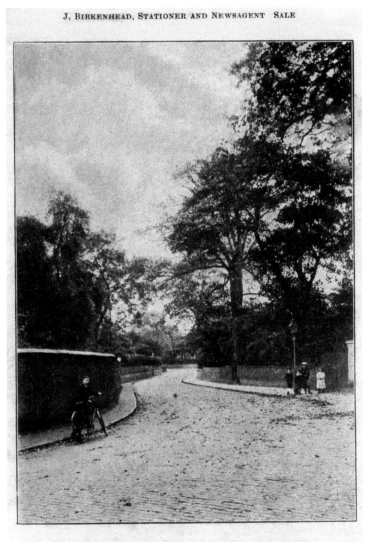

J. BIRKENHEAD, STATIONER AND NEWSAGENT SALE

Ashton Lane, Ashton-on-Mersey

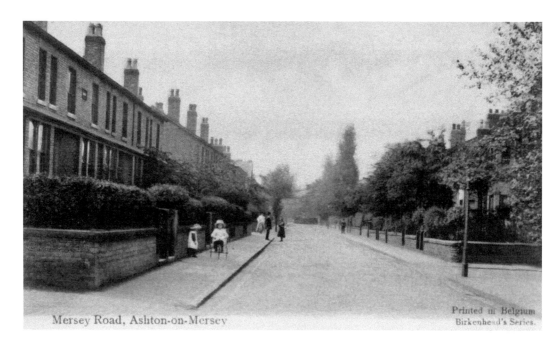

Mersey Road, Ashton-on-Mersey

Printed in Belgium
Birkenhead's Series.

Mersey Road, Ashton-on-Mersey, 1905 & *c.* 1905

Two views of Mersey Road – a colour Birkenhead's Series postcard and a black and white image, both with plenty of activity taking place in the road. We can see children playing in the road and a 'pram' being pushed along the pavement. These were common sights in postcard images of the time, made possible by the fact that there is no road traffic to be seen. Today, like most main roads in the district, it is very busy. The image is probably taken at the junction of Doveston Road, on the left, and Arnside Grove on the right. Mersey Road's junction with Cross Street can be seen straight ahead. The properties on the left have now been replaced by a modern development but were typical houses of their time.

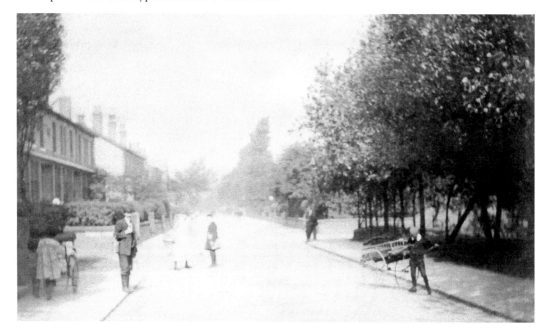

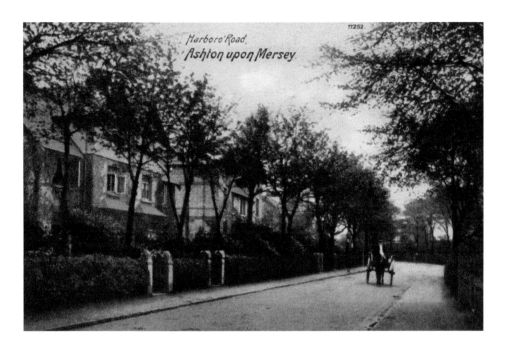

Harboro Road, Ashton-on-Mersey, 1908 & 1903

Two postcard images of Harboro Road show Ashton-on-Mersey before the advent of the motor car. The colour postcard (above) shows a solitary horse and cart in the road, whilst the black and white postcard, in the Fielding's Series (below), shows us children happily playing with their bicycles in the thoroughfare. The colour postcard clearly shows us some of the more substantial suburban properties that initially lined Harboro Road when it was first developed in the Victorian/Edwardian era. Although those properties belong to people who are more affluent than on Mersey Road, for example, the two sets of images plainly illustrate the different pace of life in Edwardian society. People relied more on public transport, or would merely walk, at a time when it was much safer to do so.

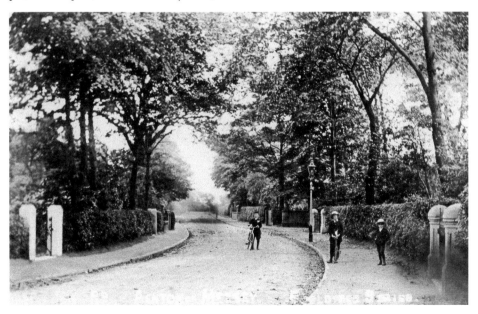

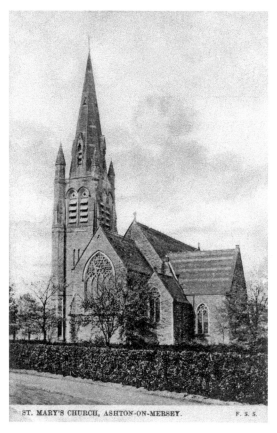

ST. MARY'S CHURCH, ASHTON-ON-MERSEY. F. S. S.

St Mary Magdalene Parish Church,
Harboro Road & Moss Lane Corner,
Ashton-on-Mersey, 1908 & 1903
The church of St Mary Magdalene
was built by public subscription,
costing £9,000 in total. The land was
donated by William Cunliffe Brooks,
the son of influential banker and Sale
landowner Samuel Brooks. It opened
on 29 March 1874, eventually becoming
an autonomous parish in 1896. Both
postcards emphasise the dominance of
St Mary's spire against the landscape,
which here is a suburban and residential
district to the north of Washway
Road. The postcard below is an early
Birkenhead's Series card. The postcards
were produced at a time when there was
still little urban development around
the church and before the suburban
development of the early twentieth
century really began to influence the
districts of Sale and Ashton-on-Mersey.
Agricultural land was still predominant
in the 1900s and change was slow.

J Birkenhead, Stationer and Newsagent, Sale.

ST. MARY MAGDALENE CHURCH, ASHTON-ON-MERSEY.

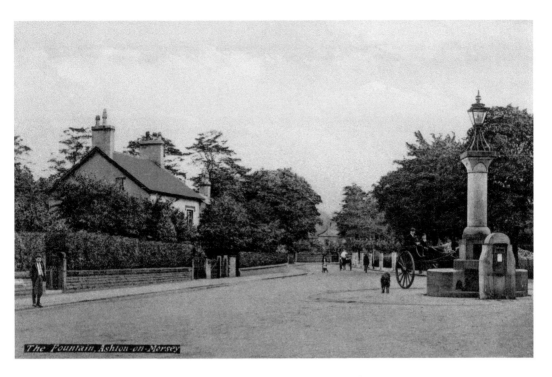

The Fountain, Ashton-on-Mersey.

Ashton Fountain, Junction of Ashton Lane & Moss Lane, Ashton-on-Mersey, 1905 & 1903

In both postcards Ashton Fountain can be seen in its original condition. The fountain's gaslight provided much-needed illumination at this junction and acted as a local landmark. Also, from the point of view of public utility, it served a valuable purpose as a drinking trough for horses and postbox, both of which can be clearly seen in the postcards of 1903/05 but are today removed. The cottage on the left is Newton Green House. The fountain was erected in 1881 by William Cunliffe Brooks. It was without its gaslight and had been moved to the side of Ashton Lane by 1965 but acquired a bench seat in the process. Today, Ashton Fountain and the postbox have been moved to the Barkers Lane side of Ashton Lane and the fountain is without its bench seat.

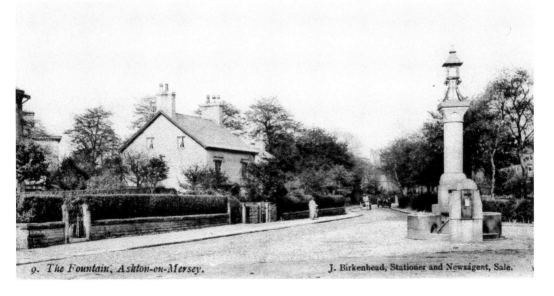

9. The Fountain, Ashton-on-Mersey. J. Birkenhead, Stationer and Newsagent, Sale.

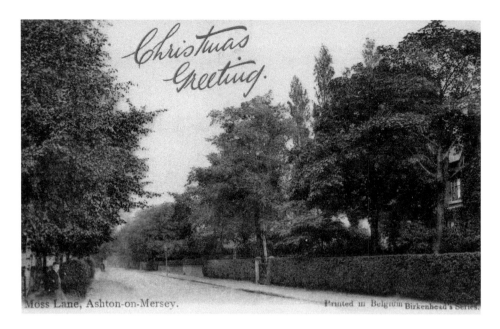

Moss Lane, Ashton-on-Mersey.

Printed in Belgium Birkenhead's Series.

Moss Lane, Ashton-on-Mersey, 1905 & 1903

These are two Birkenhead's Series postcard images of Moss Lane. The above colour image bears the message 'Christmas Greetings' and tells us that it was printed in Belgium, whilst the black and white image below shows us the original view. The festive message above was popular on postcards of the Edwardian period. The sharp and finely honed colours of this postcard give us a sense of the real depth and detail present in this view, which we do not get on the postcard below. This is number eighteen in a series by 'J. Birkenhead, Stationer and Newsagent, Sale'. Moss Lane forms a junction with Harboro Road, at the site of St Mary Magdalene parish church, which is at its southern end; and a junction with Ashton Lane, at the former Ashton Fountain, at its northern end.

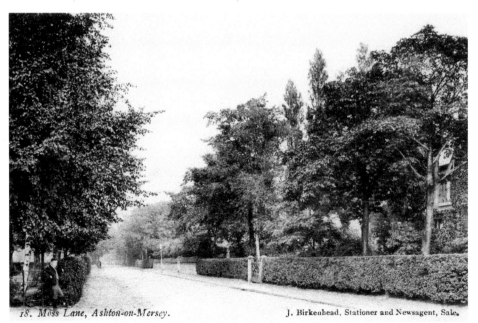

18. Moss Lane, Ashton-on-Mersey.

J. Birkenhead, Stationer and Newsagent, Sale.

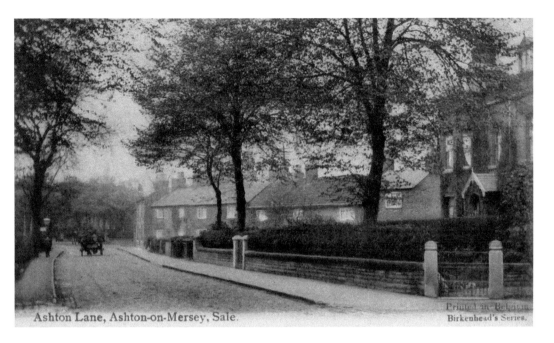

Ashton Lane, Ashton-on-Mersey, Sale.

Printed in Belgium
Birkenhead's Series.

Ashton Lane Junction with Ashton Grove, Ashton-on-Mersey, 1905 & 1903

In 1903 the cottages shown in these Birkenhead's Series postcards of Ashton Lane were typical of the area. Looking towards Ashton-on-Mersey, Sale Baptist Church is on the left. The cottages were at the junctions of York Road (previously Ashton Grove) and Cranleigh Drive. They were demolished in 1969 for the creation of a roundabout. The delicately coloured postcard of Ashton Lane (above) presents a rural idyll which is now difficult to visualise at this busy junction. Cottages, horses and carts and a gas lamp provide real period themes. The black and white postcard below tells us that it is number two in a series, sold by 'J. Birkenhead, Stationer and Newsagent', who were located on Washway Road, Sale, close to the junction where this postcard view was taken.

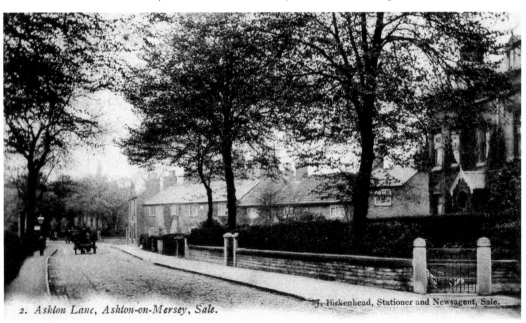

2. Ashton Lane, Ashton-on-Mersey, Sale.

J. Birkenhead, Stationer and Newsagent, Sale.

53

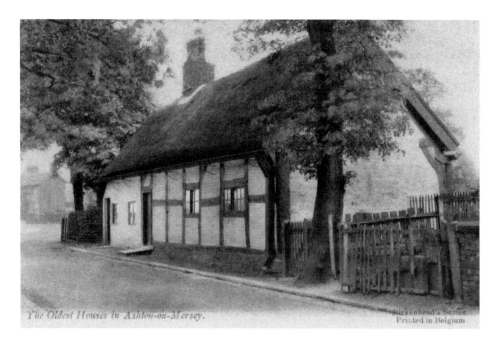

The Oldest Houses in Ashton-on-Mersey.

Birkenhead's Series.
Printed in Belgium.

'The Oldest Houses in Ashton-on-Mersey', Old Rectory, Church Lane, 1928 & 1903

In 1937 these old thatched cottages were demolished, many years before Church Lane was declared a conservation area. Built in the seventeenth or early eighteenth century, and once housing the curates of St Martin's Church, today this plot has been utilised for modern housing. Some of the original buildings surrounding it remain, including the row of terraced housing shown in the background of the original postcards. Brick walls on either side of Church Lane in 1903 remain today. The postcard of the 'Old Rectory' in the 'Oldest Houses' series, number seven on the black and white postcard below, gives us an idea of the former rural aspect of this once agricultural village. Timber frames and thatched roofs were a common feature across Cheshire until the urban expansion of the nineteenth and twentieth centuries.

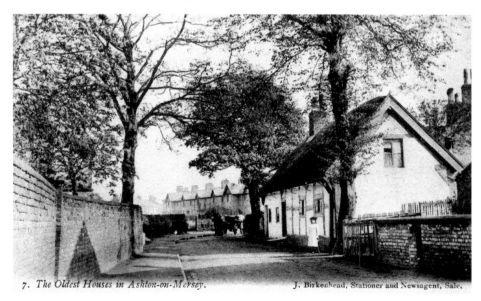

7. The Oldest Houses in Ashton-on-Mersey.

J. Birkenhead, Stationer and Newsagent, Sale.

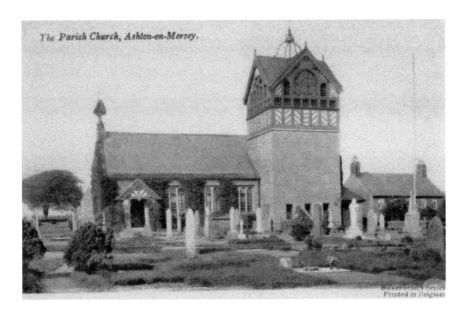

The Parish Church, Ashton-on-Mersey.

St Martin's Parish Church, Ashton-on-Mersey, 1905 & 1903

The first church was built in the late ninth century, in the time of the Saxon king Edward the Elder. This was followed by a structure, built in 1304, by Willemus de Salle, the first rector of St Martin's, which was destroyed by a storm in 1704. A new church was built in 1714 near Ashton Old Hall, with additions in 1874 and 1886. In 1887 a new church tower, vestry and lychgate were built, designed by George Truefitt. The colour Birkenhead's Series postcard above clearly shows detail on the church tower and graveyard, before its trees had begun to mask a lot of those features. The black and white postcard below, taken from a similar angle, is an earlier view of the parish church, which again shows us the church tower of 1887.

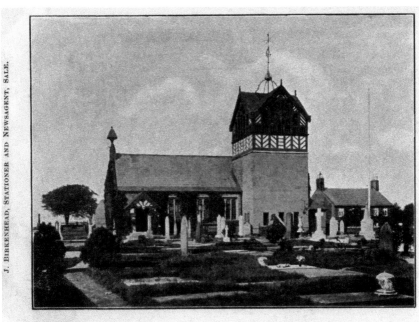

The Parish Church, Ashton-on-Mersey.

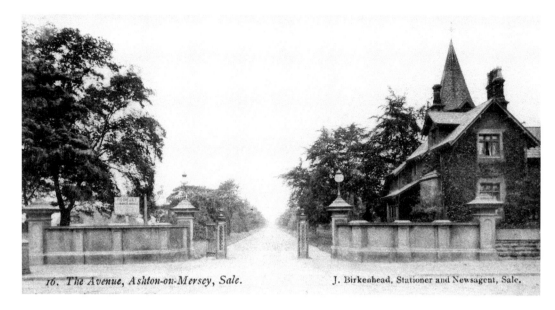

16. *The Avenue, Ashton-on-Mersey, Sale.* J. Birkenhead, Stationer and Newsagent, Sale.

The Avenue, Ashton-on-Mersey, 1903

Shown in these two postcards of 1903 is a gate and lodge at The Avenue's junction with Washway Road. This was home to a gatekeeper serving mansions like Oakleigh, Woodheys Grange and Ashleigh. The lodge still had its spire in 1903, which acted as a local landmark at this time, but it is now no longer standing. The Birkenhead's Series postcard number sixteen (above) shows the lodge in relation to Washway Road, with its now removed spire. The sign visible on the left reads, 'TO BE LET A MANOR HOUSE, THE AVENUE.' The postcard below gives us a view of the gates and lodge and looks along The Avenue from Washway Road. They are interesting views of the original forerunner of the 'gated' communities that we find in suburbs today.

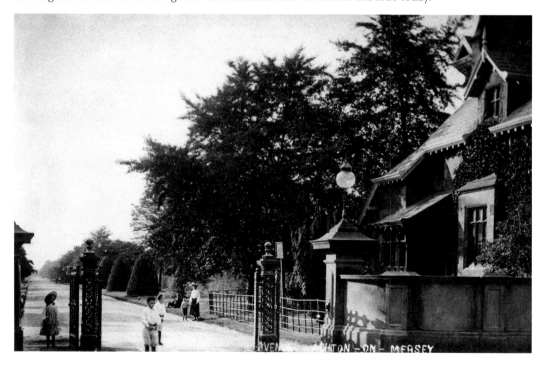

CHAPTER 4
SALE AND BROOKLANDS

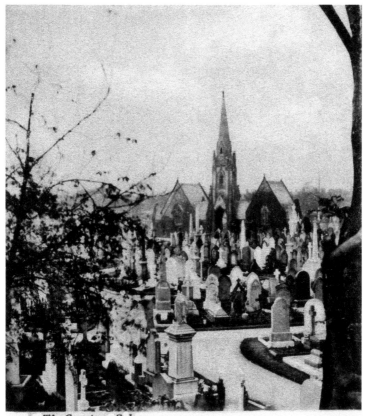

13. The Cemetery, Sale

J. Birkenhead, Stationer and Newsagent, Sale.

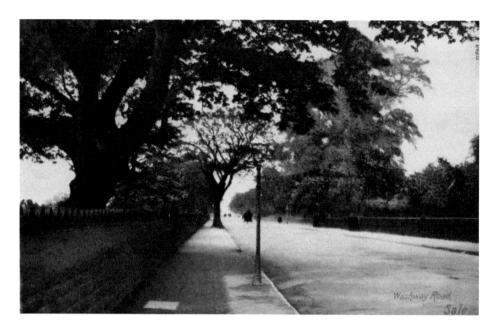

Washway Road, Sale, 1905

Cross Street and Washway Road originally formed part of the Roman road between Manchester and Chester, now referred to as the A56. In the eighteenth century Turnpike Trusts were set up under local acts in order to maintain the deteriorating road system. The Washway Turnpike Act was passed in 1765 and a toll house was built at Crossford Bridge. The toll bar was abolished in 1885 and in 1888 the Local Government Act made the new County Councils responsible for their repair. The roadway was originally structured so that the camber of the highway's surface would cause water to run off and thereby clear it of any excess debris. The road surface would also become impacted as a result of the weight of constant traffic across it, thus making a serviceable thoroughfare.

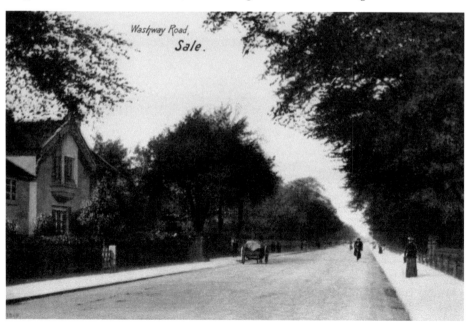

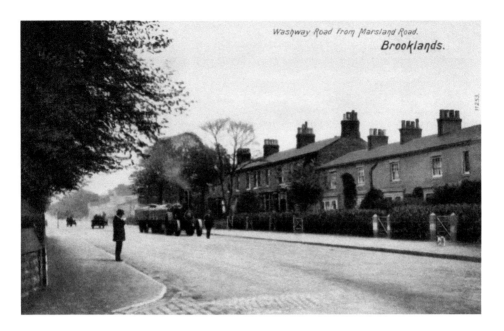

Washway Road from Marsland Road.

Brooklands.

Washway Road from Marsland Road, Brooklands, Sale, 1905 & 1906

On 17 August 1906 the tramline to West Timperley was officially opened to the public. Originally the tramline ran from Manchester to Stretford and was extended to Sale, then eventually to Altrincham by 1907. A policeman patrols this busy junction, whilst a well-dressed Edwardian lady (probably a photographer's model) can be seen in the 1906 postcard (below). The traction engine in the colour postcard (above) is an interesting addition, as it was only another two years before electric trams were passing this spot – a timely reminder of the speed of change. A man can also be seen walking in front of the traction engine, as an additional safety measure and warning to over-inquisitive pedestrians. This image clearly predates 1906, as there are no noticeable tramlines along this section of Washway Road.

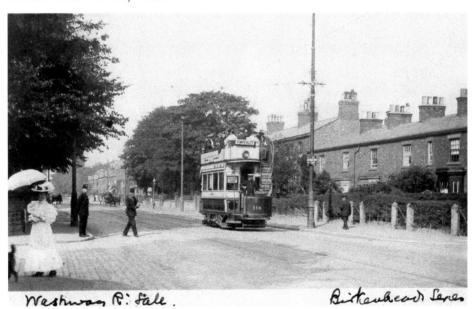

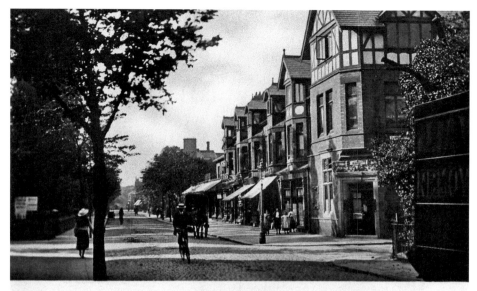

SCHOOL ROAD, SALE.

School Road from Claremont Road & Stanley Grove, Sale, 1915, & from near Washway Road, 1961

Parr's Bank stands on the far right of School Road, at its junction with Curzon Road, in this postcard view (above) looking towards Washway Road and Cross Street junction in 1915. School Road's junction with Claremont Road is on the right of the 1915 postcard, whilst Stanley Grove is on the left and opposite Claremont Road. The row of shops on the right once housed Boots the chemist and W. H. Smith, booksellers. The postcard below shows that there is a clear view looking towards Sale town hall and railway station, at Sale Bridge, in 1961. The former Parr's Bank, on the near left in 1961, has now become the National Westminster Bank. In later years the bank became a restaurant and public house and the clear view to Sale Bridge became obscured.

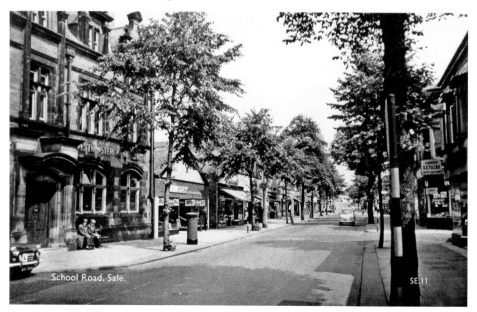

School Road, Sale.

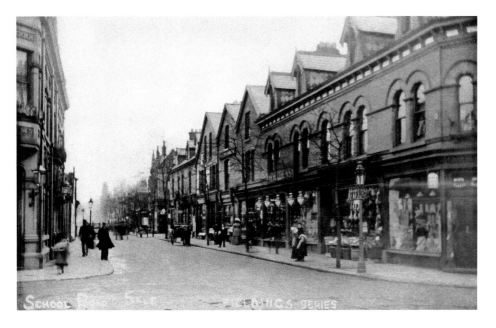

School Road Junction with Cross Street, Sale, 1906 & *c.* 1900

The Fielding's Series postcard of 1906 (above) is taken from the Cross Street/Washway Road junction with School Road, whilst the unusual vignette postcard of around 1900 (below) is taken from opposite Orchard Place and looks towards the well-known Bull's Head Hotel on the right, and towards the Cross Street/Washway Road junction straight ahead. The Bull's Head dates from 1830 and was completely rebuilt in 1879. Cross Street takes its name from the cross that once stood at the north end of Crossford Bridge, Stretford. This was at the junction of Chester Road and King Street, opposite the now demolished Trafford Arms Inn. The base of the cross, inscribed in commemoration of its removal, is now to be found in the nearby graveyard of St Matthew's parish church, Stretford.

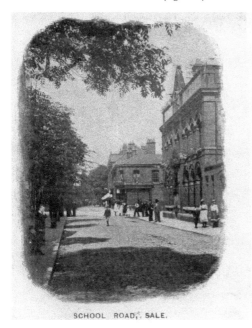

SCHOOL ROAD, SALE.

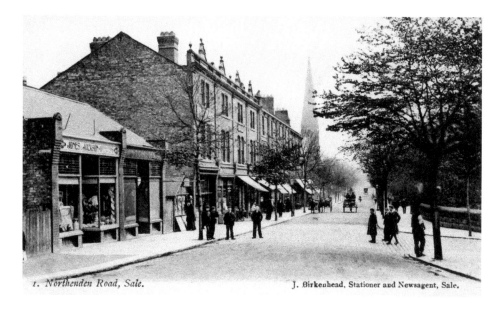

1. *Northenden Road, Sale.* J. Birkenhead, Stationer and Newsagent, Sale.

Northenden Road & Broad Road Junction, Sale, 1903, & from Hope Road Junction, 1915
In 1867 Northenden Road was known as Moor Lane at Sale railway station and Hart Lane at the Northenden boundary. In 1868 the whole length was renamed Northenden Road. Sale Tramway was opened in 1906 but it was not until 1912 that the tramline was extended to the Legh Arms, in Sale Moor. Therefore, the postcard of Northenden Road in 1915, shown below, highlights the tramlines and trams heading towards the railway station and Sale. The shop sign to the left, on the 1903 Birkenhead's Series postcard above, confirms that the premises belong to Jones & Jackson, described in Slater's Directory of around 1900 as 'Painters, furnishers and decorators and dealers in Japanese goods & c. Showrooms: 3 Northenden Road, Sale.' The original woodyard of Jones & Jackson later became a bar and live music venue.

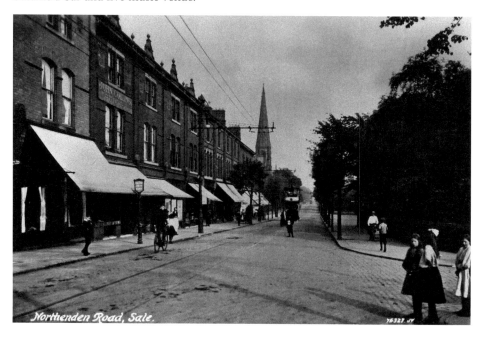

Northenden Road, Sale.

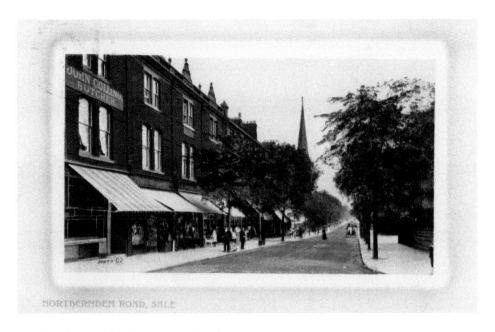

Northenden Road looking towards Sale Moor, 1905 & pre-1912

Robert Oxton Bolt CBE (1924–95) was born at No. 13 Northenden Road, shown on the above colour postcard on the left-hand side. His father's furnishing store is today commercial premises and displays a commemorative plaque. Bolt wrote *A Man for All Seasons* and several screenplays, winning an Oscar for the Best Adapted Screenplay. Sale Waterside's Robert Bolt Theatre is named in his honour. Today, the retail premises of 1915 remain, with some modern development at the far end. The spire belongs to Sale Presbyterian Church, built in 1874 at the junction of Northenden Road and Woodlands Road, and redeveloped in 1968. The site is now occupied by an office block. The postcard below shows a horse-taxi rank on the left side of Northenden Road and dates from before 1912. It is still used by taxis today.

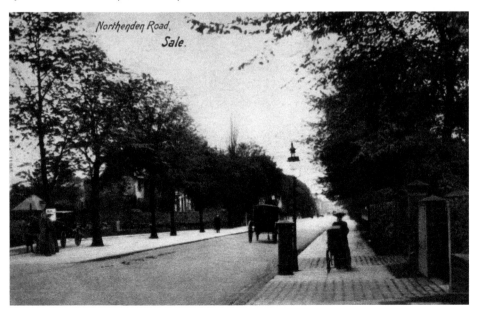

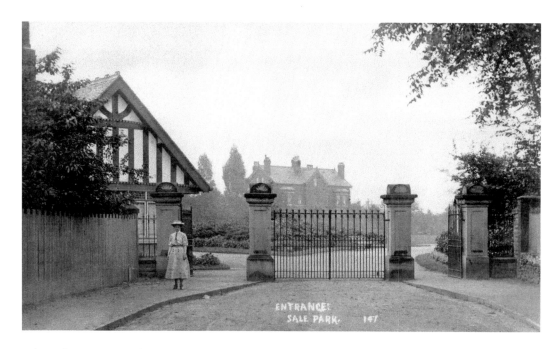

Sale Park, Gates & Lodge, Cheltenham Drive, 1914 & 1903
Sale Park opened on 30 June 1900 and was renamed Worthington Park in 1949, after Mary Worthington of Sale Lodge, the widow of James Worthington, who had been a member of the Sale Local Board. Mary Worthington's initially anonymous financial donation led to the park's establishment. A total of 2,500 Sunday school children were invited to attend the park's opening. The lodge, on Cheltenham Drive, formerly housed a full-time park keeper and according to the date stone was built in 1898. The park's original facilities included a bandstand, ornamental lake, formal flower beds and summerhouses. It covers 16.5 acres and has a memorial to Sale scientist James Prescott Joule (1818–89), who lived for many years on Wardle Road. It was also home to a stone lion, which was removed to the Sale Waterside complex.

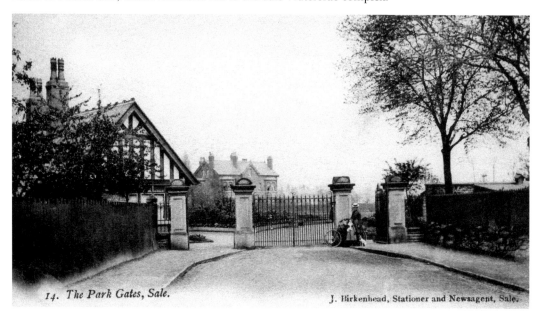

14. The Park Gates, Sale. J. Birkenhead, Stationer and Newsagent, Sale.

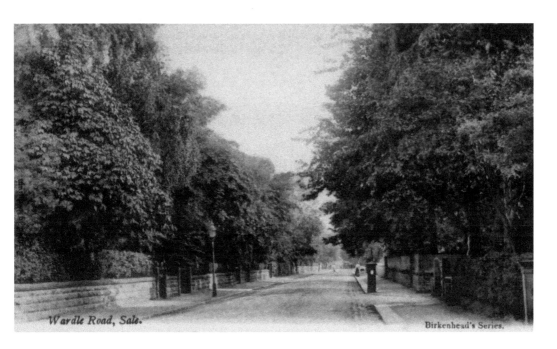

Wardle Road, Sale, *c.* 1905 & 1912

Rutland House, at No. 12 Wardle Road, on the right-hand side of the 1912 photograph below, was once the home of the famous scientist and physicist James Prescott Joule. He lived here for the last seventeen years of his life. Joule's theories led to the Joule and the Kilojoule becoming the standard measurements for energy. There is a memorial to Joule in Worthington Park and more recently a bar on Northenden Road was named after this famous one-time resident. Wardle Road runs between Northenden Road and Marsland Road. The colour postcard in the Birkenhead's Series (above) shows Wardle Road as a typical well-to-do suburban district of Sale. The photo-postcard of Wardle Road, below, looks in the other direction and gives us a glimpse of some typical properties on the right.

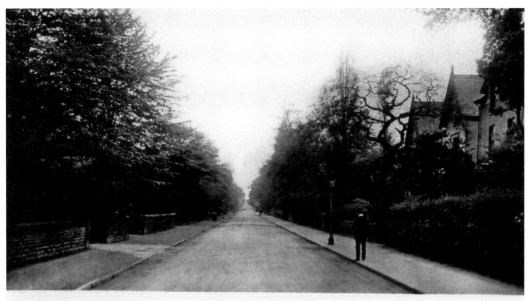

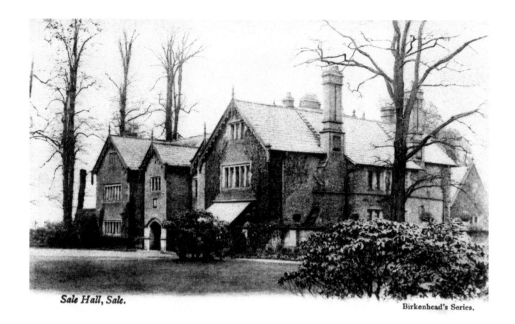

Sale Hall, Sale.

Birkenhead's Series.

Sale Old Hall, Junction of Rifle Road & Old Hall Road, 1900

These Birkenhead's Series postcards give us a colour (above) and black and white (below) photo-view of Sale Old Hall from similar angles. These postcards give us an insight into an aspect of Sale's history now long forgotten. The site of this illustrious old hall now lies beneath the route of the M60 motorway and its extensive foundations, which have been widened in recent years – yet another sacrifice to the relentless march of progress. In 1900 Sale Old Hall was the residence of Sir William Bailey, who erected the 'Togo' pagoda in its grounds. The hall and ancillary buildings were demolished in 1920, but the Dovecote, built in 1895, remained, later being relocated to a motorway roundabout. It is now sited at Walkden Gardens, on Marsland Road, following the widening of the M60 ring road.

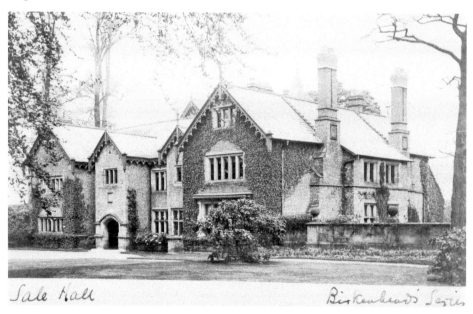

Sale Hall

Birkenhead's Series

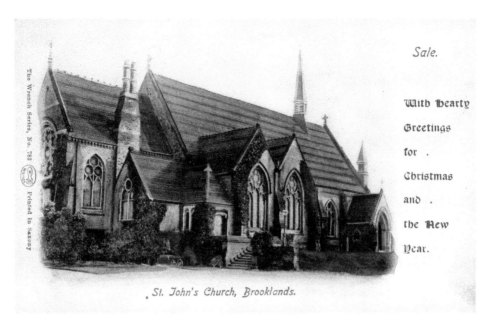

Sale.

With hearty
Greetings
for .
Christmas
and .
the New
Year.

. St. John's Church, Brooklands.

St John the Divine Parish Church, Brooklands, Sale, 1903 & *c.* 1905

These Wrench Series postcards, which are printed in Saxony, give us a festive view of St John the Divine at Brooklands in colour (above), which announces, 'With hearty Greetings for Christmas and the New Year.' The black and white print (below) does not have these embellishments, which were popular at the time, and is presented in very similar style to an engraving. In 1856 the Manchester entrepreneur Samuel Brooks purchased the land for St John the Divine, which was built by Manchester architect Alfred Waterhouse between 1864–68 and opened on 9 April 1868. The church is located on the Trafford side of Brooklands boundary with Manchester. There is a church hall at the back of St John the Divine, which was built in 1968, replacing the parish room on Marsland Road.

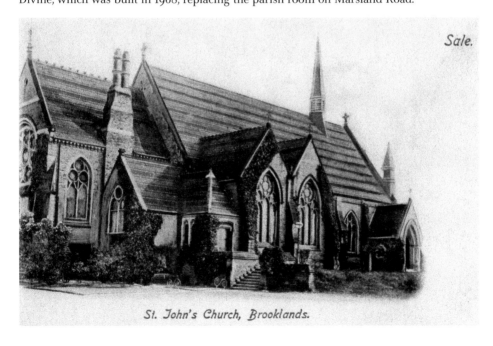

Sale.

St. John's Church, Brooklands.

CHAPTER 5

DUNHAM MASSEY AND BOWDON

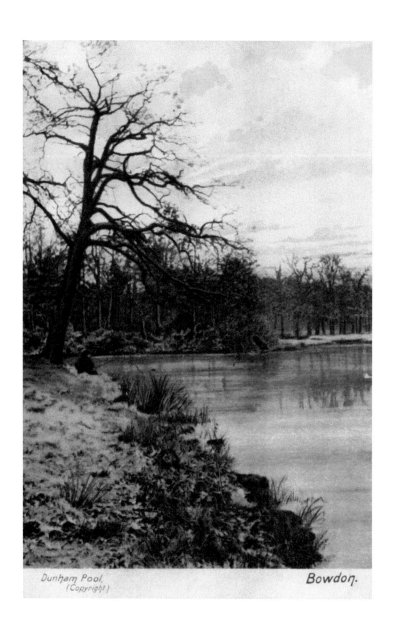

Dunham Pool.
(Copyright.)

Bowdon.

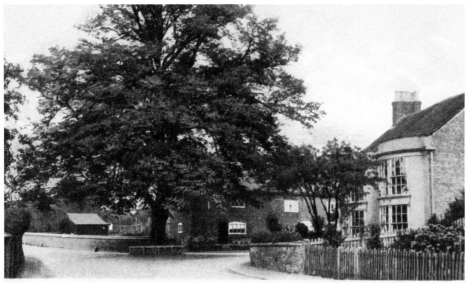

Dunham Town, Altrincham.

Dunham Town, Dunham Massey, 1900, & Altrincham Entrance to Dunham Park, Dunham Road, 1903

The colour postcard above, which is printed in Saxony, shows Dunham Town around 1900, with Dunham Park and hall lying to its south. This view has changed little since the 1900s. In the Domesday Book Dunham Massey was known as 'Doneham', and belonged to the de Massey family and later the Earls of Stamford. The Wrench Series view of 1903 below looks towards the now removed spire of St Margaret's Church, on Dunham Road, in the direction of Altrincham. The gate is still there and is now part of the public footpath leading to Dunham Forest Golf and Country Club. Written to 'DG', it says, 'I was sorry you were not at home when I called but will call next Wednesday evening just to see you. HF.'

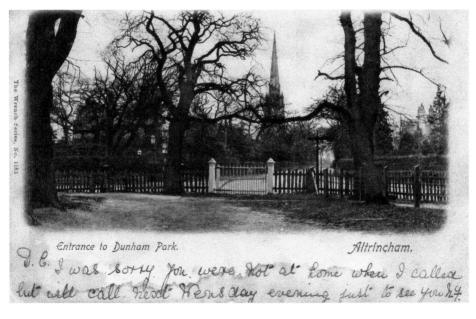

Entrance to Dunham Park. *Altrincham.*

D.G. I was sorry you were not at home when I called but will call next Wensday evening just to see you HF.

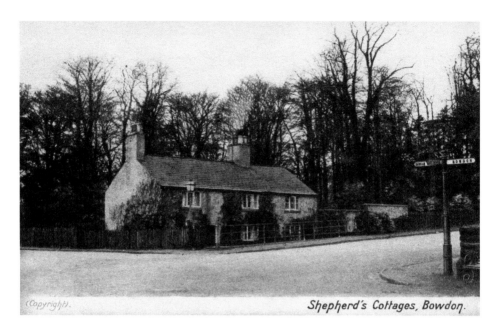

Shepherd's Cottages, Bowdon.

(Copyright).

Shepherd's Cottages, Dunham Hill, Dunham Road, Bowdon *c.* 1900 & 1914

These postcards show the busy junction of Charcoal Lane and 'Dunham Hill' (Dunham Road) where Shepherd's Cottages are located. To the left of both images is 'Parklands', a Victorian mansion of red brick and stone built in 1887–88 by William Berry, a Manchester businessman who had made his fortune in the wholesale blacking trade, and built property along Stamford New Road and in Hale. 'Parklands' was sold in 1963 and until 1994 it was the base of the Institute for the Study of Hierological Values. Both postcards look towards Altrincham, with Charcoal Lane (left) heading towards Dunham Massey, hall and park, and Park Road (right) heading towards Bowdon. Shepherd's Cottages (below) on the left, has wisps of smoke from one of its chimneys, whilst a motor car of period design approaches the junction.

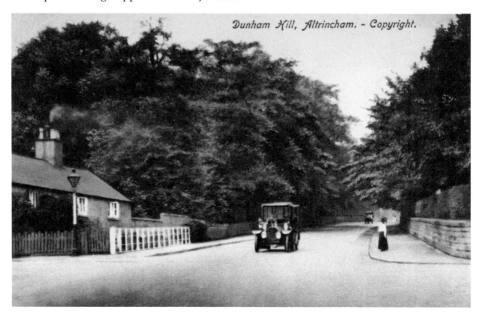

Dunham Hill, Altrincham. – Copyright.

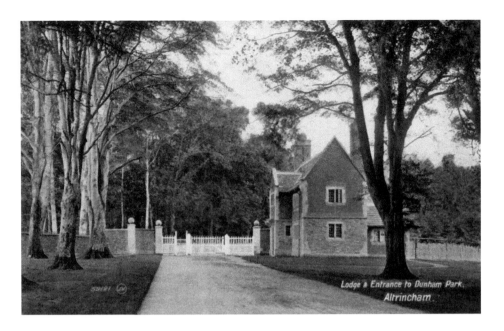

Lodge and Entrance to Dunham Park, 1908, & Lodge Brow, 1909

The lodge and entrance to Dunham Park is located at the junction of Charcoal Lane and Main Drive. The postcard of 1908 (above) looks towards Charcoal Lane, with Main Drive behind the photographer stretching through the woodland of Dunham Park, in the direction of Lodge Brow (below) and Dunham Hall. The drive shown in both postcards would have been used by the Earls of Stamford and their coach and horse teams when entering and exiting the hall and park. Today it provides walkers with a pleasant vista. The walls and gates, which can be seen in the postcard above, were designed to admit visitors whilst keeping the Fallow Deer population restricted! The postcard view of Lodge Brow (below) in 1909 shows us the road beginning to slope away beyond the two trees in the centre.

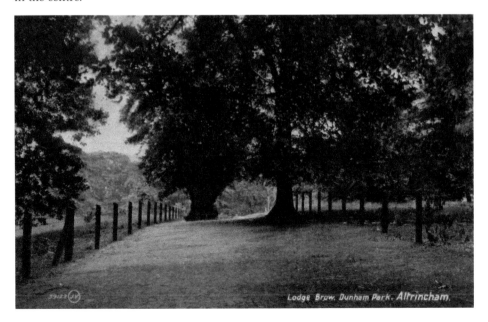

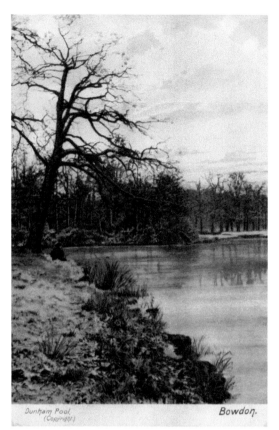

Dunham Pool,
(Copyright)

Bowdon.

Dunham Pool, Bowdon, 1906, & Old Mill, Dunham Park *c.* 1905

These colour postcards emphasise two of Dunham Park's more prominent water features. The sawmill (below) was originally a corn mill, constructed in the seventeenth century, and is Grade II listed. It is a rare working example of a seventeenth-century watermill, which underwent restoration in 1980. There is a reconstructed overshot waterwheel, carpenter's shop and water-powered machinery. The mill's attic was formerly a granary. Dunham Pool (above) is one of the park's many attractive structures and emphasises the importance of a regular water supply to the daily functioning of the medieval manor. Also present since ancient times is the park's herd of fallow deer, which are very tame and tolerant of visitors. The original manor's economy would have also relied heavily on forestry. Some of the oaks here date back to the seventeenth century.

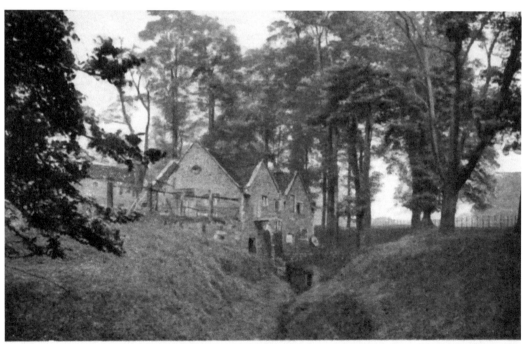

OLD MILL DUNHAM PARK BOWDEN CHESHIRE Copyright. F. F. & Co.

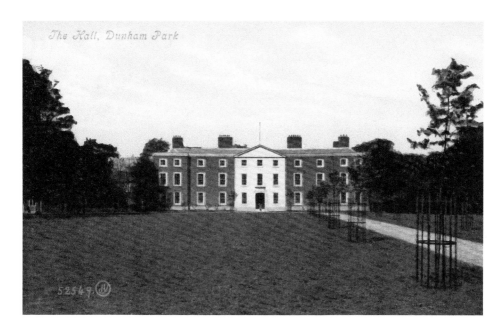

The Hall, Dunham Park

Dunham Hall, Dunham Park, 1910 & *c.* 1905

The postcard of 1910 shows a formal view of the hall (above) whilst the one of around 1905 (below) gives a view across the park. A motte-and-bailey Norman castle once occupied the site and a chapel was here as early as 1307. In the early seventeenth century a house around a courtyard was built, although little of this survives. John Norris designed the main house in 1732–40, with some additions by John Shaw in 1822. Joseph Compton Hall further altered the building in the Edwardian period. The hall was empty for around fifty years at the end of the nineteenth century, until the 9th Earl of Stamford returned to Dunham in June 1906. The 10th Earl, Roger Grey, remained unmarried and so the property eventually came into the possession of the National Trust, opening in April 1981.

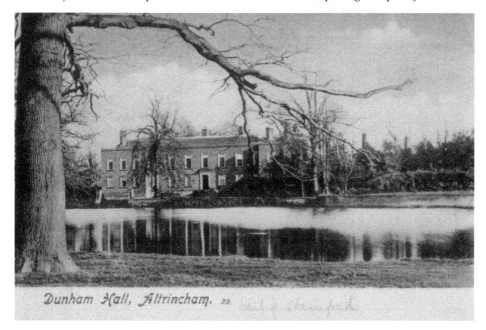

Dunham Hall, Altrincham.

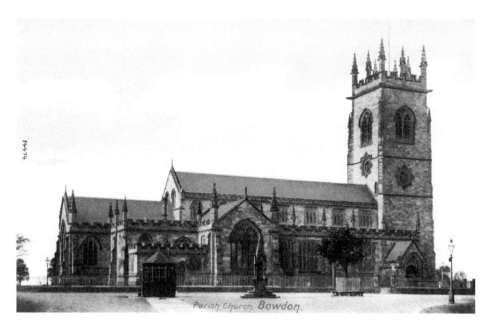

Parish Church Bowdon.

St Mary the Virgin, Stamford Road, Bowdon, *c.* 1900 & 1905

In the churchyard there are three Grade II listed structures. The first is a sandstone sundial post of unknown date. There is also a sandstone war memorial from around 1920 by Arthur Hennings. The third structure is the piers, railings and walls surrounding the churchyard. The church of St Mary the Virgin is a Grade II listed building. Dating from the time of the Domesday Book, a new church was built in the fourteenth century, remodelled in the sixteenth century and completely rebuilt in 1858–60 by W.H. Brakspear. The colour postcard of the church (above) is taken from Stamford Road, in the centre of Bowdon, whilst the postcard below shows the view from the other side of the church and displays the section of graveyard that is closest to it. There is a notable steep gradient from right to left.

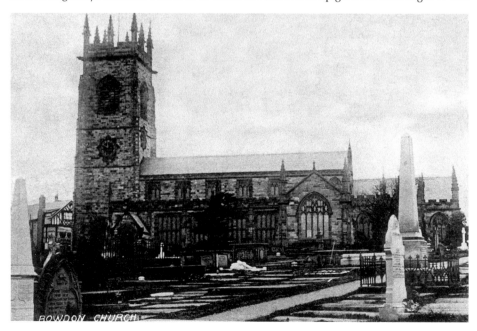

BOWDON CHURCH

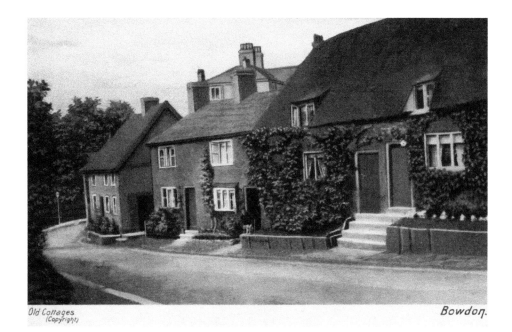

Old Cottages *(Copyright)* *Bowdon.*

Church Brow Cottages, Church Brow, Bowdon, 1904, & Langham Road Cottages, 1908
This pair of postcards shows examples of Bowdon's cottages in the pre-urban era. The cottage at Church Brow (above), located below the passage, was thatched up to 1914. The Grade II listed Bowdon Old Forge is also found here. The cottages on the right of nearby Langham Road (below) are dated AD 1640 and in 1908 they were still thatched and ivy-clad, which appears to have caused damage to their side wall. The wall opposite these cottages surrounds Bowdon parish church's graveyard and is a Grade II listed structure. The steep gradient noted in the graveyard of St Mary the Virgin parish church is continued at Church Brow, which then heads downhill towards Park Road. The church wall here runs onto Park Road and forms a boundary between the road and graveyard.

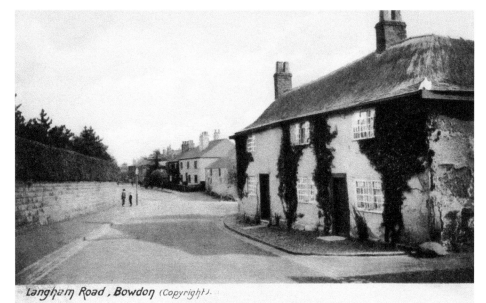

Langham Road, Bowdon (Copyright).

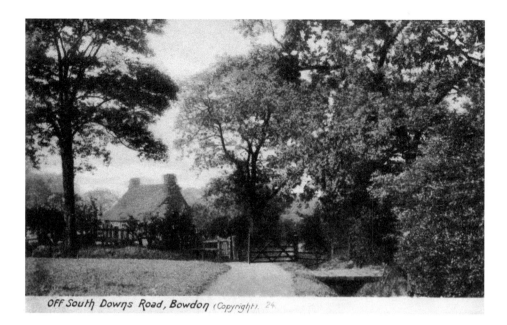

Off South Downs Road, Bowdon (Copyright). 24

Off South Downs Road, Bowdon, *c.* 1900, & The Firs, Altrincham, *c.* 1900

In the latter part of the nineteenth century urbanisation of the district advanced at a rapid rate, with mains water introduced in 1864 and gas lighting in 1865. Many of the larger mansion houses and villas belonging to Manchester business owners were constructed along South Downs Road in this same period of economic and social development. It is also the home of Bowdon Cricket Club. The club was founded in 1856 and first played at South Downs Road in 1865, with a pavilion built in 1874. The Firs, below and nearby, was developed in the mid-nineteenth century and forms a junction at the village of Bowdon with Stamford Road, Green Walk and Church Brow at its centre and directly opposite Bowdon parish church. Both postcards illustrate the tranquil suburban nature of the district.

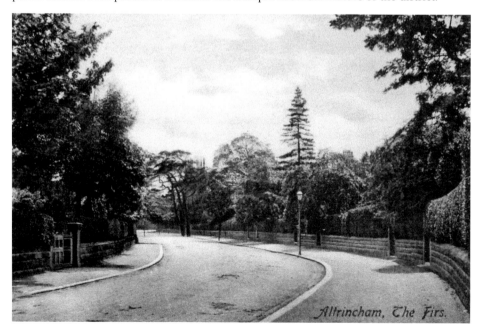

Altrincham, The Firs.

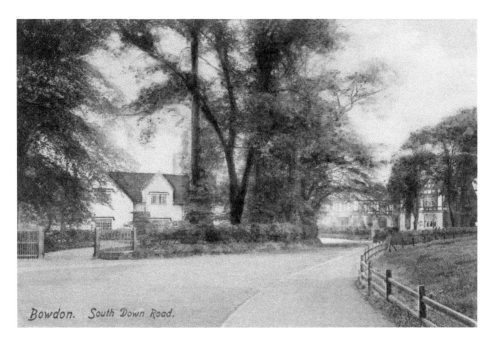

Bowdon. South Down Road.

South Downs Road, Bowdon, 1904, & Ashley Heath, Bowdon, 1906
This area of South Downs Road is known as Ashley Heath, as emphasised by the two postcard images, which are taken from the same site two years apart. The road junction here was wider in 1904 (above) and there is an earth bank and hedges directly opposite, which had been removed and replaced by a stone wall with a wooden fence on it by 1906 (below). These postcards show us that even in a relatively short space of time the outlook of an area can change significantly. They also clearly illustrate the reasons why this area of Bowdon was popular with Manchester merchants and business people. The properties shown are pleasant and sizeable and the black and white timber-framed houses on the right echo the black and white timber frames of medieval Cheshire farmhouses and manor houses.

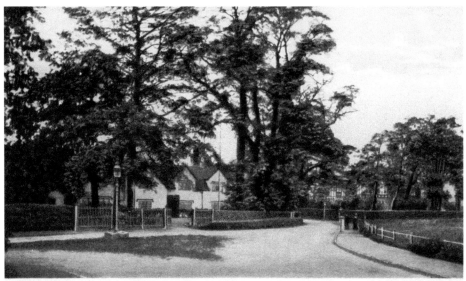

Ashley Heath.
(Copyright)

Bowdon.

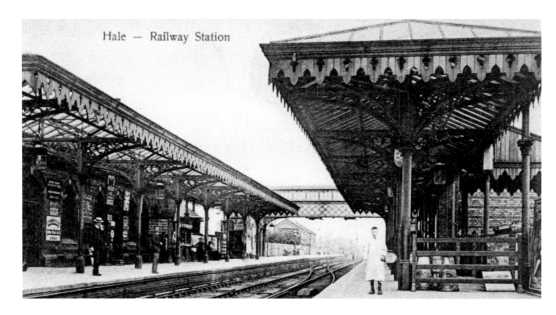

Hale Railway Station, Ashley Road, 1906 & *c.* 1900

The postcard of 1906 (above) shows us some good detail of the station canopies and platforms, whilst the postcard of around 1900 (below) shows us how the signal box configures in relation to the rest of the station. The colour postcard below, in the Perfection Series, shows us that Hale station was very busy in the 1900s. We can see hansom cabs waiting outside and many passengers standing on the platform for the next train. The man walking towards the camera, in the centre of the postcard, would appear to have a cat following him! Today, the signal box is no longer in use and the area in front of the station is now a car park. The station opened on 12 May 1862, is on the Manchester to Chester line, and is Grade II listed. To the left of the signal box is the Cheshire Midland public house, named after the company who constructed the station and line.

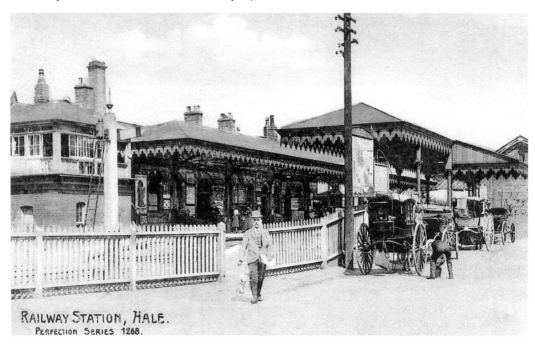

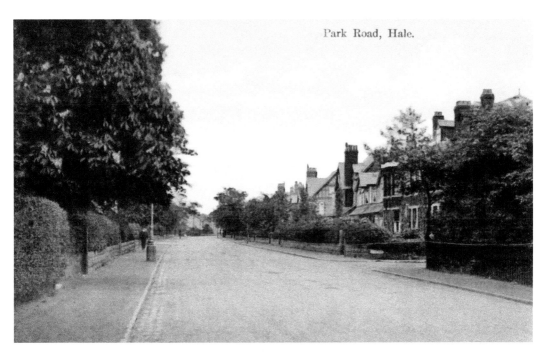

Park Road, Hale, 1911 & 1963
Park Road stretches from its junction with Ashley Road in the west to its junction with Hale Road at its eastern end. It is one of the wide 'leafy' roads typical of the area. Note also the Cheshire sandstone walls, which are widespread in this district and make use of the local stone once quarried here. The roads are wide and relatively peaceful compared to the more congested traffic conditions of the twenty-first century and its related parking issues. Many of the early properties here are Edwardian in design, as shown in the 1911 postcard above, and have changed little in the intervening years. The area remains tranquil and picturesque, despite subsequent suburban development throughout the 1930s and into the twentieth century, as shown in the postcard of 1963 below.

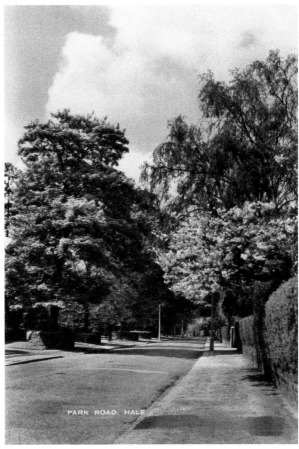

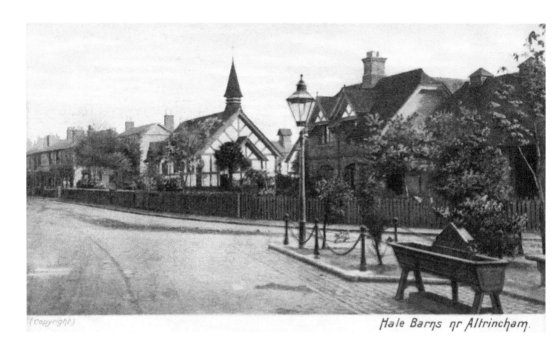

Hale Barns nr Altrincham.

Hale Barns Mission Church, Hale Road, 1908 & 1905

The Mission Church at Hale Barns was built in 1881, opening on St Paul's Day 1882 and adopting this name. It was a chapel to Ringway St Mary and All Saints, closing in 1967, with Hale Barns All Saints built on the site. The village is named after the now demolished Tithe Barns. In 1723 a Unitarian chapel was also constructed in Hale Barns, on Chapel Lane, for the Presbyterian community. They pioneered education in the district and built a school. The two postcards featured here give us the main structures of the village centre from different angles. These are the Mission Church and surrounding cottages, with a horse trough and a bench seat in the foreground. The postcard below gives us more detail of the cottages next to the Mission Church.

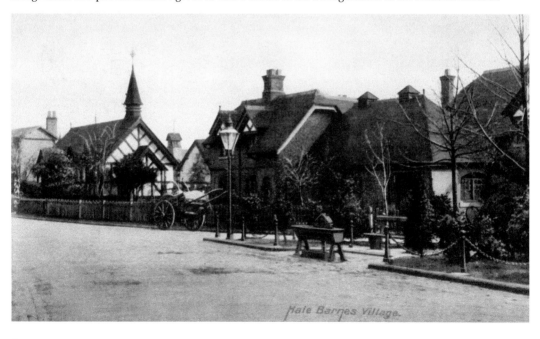

Hale Barnes Village.

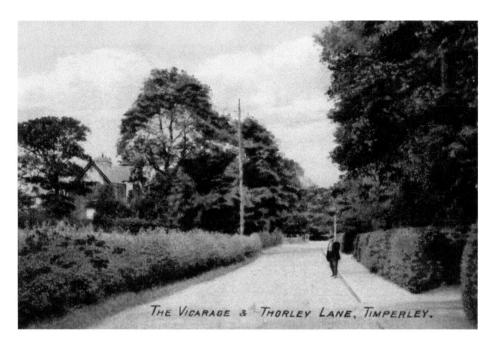

THE VICARAGE & THORLEY LANE, TIMPERLEY.

The Vicarage & Thorley Lane, Timperley, 1908, & Mayfield Road *c.* 1960

The parish of Christ Church, at Thorley Lane, was formed in 1852 and is in the Deanery of Bowdon, part of the Diocese of Chester. Nearby Timperley Village was originally a centre of farming in the nineteenth century (above). By the turn of the twentieth century it had become a residential area for merchants and industrialists working in Manchester. Urbanisation increased to a peak in the 1930s, with a raised level of housebuilding and the development of the suburb we know today (below). Neighbouring Mayfield Road forms a junction with Stockport Road in the centre of Timperley. It is another typical 'leafy' suburban road, developed when much of Timperley and the surrounding area was given over to housing in the 1930s. The postcard of around 1960 below shows semi-detached houses of typical 1930s style.

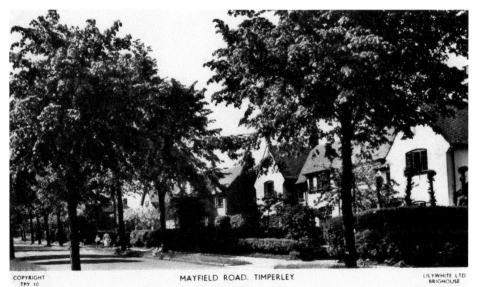

COPYRIGHT
TPY 10

MAYFIELD ROAD. TIMPERLEY.

LILYWHITE LTD
BRIGHOUSE

CHAPTER 6

ALTRINCHAM

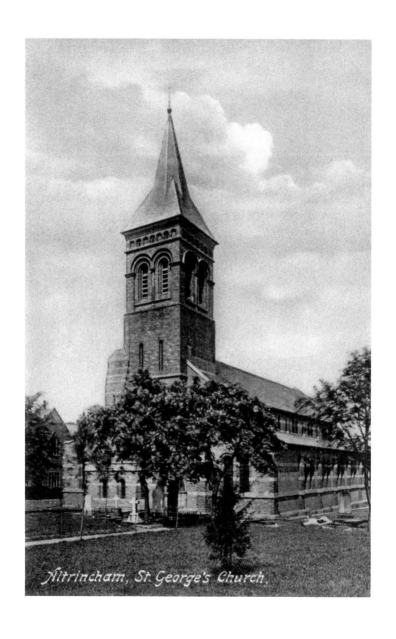

Altrincham, St George's Church.

Altrincham 'Multi-views', 1913 & c. 1920
This colour postcard 'Multi-view'
of Altrincham (above) has views of
Manchester Road (top), one of the main
routes into/out of Altrincham; George
Street (centre), one of the main shopping
streets; and the Conservative Club (below)
influential in local politics at the time.
The 'Multi-view' postcard of around 1920,
a 'Souvenir of Altrincham' (below), shows
us the Hippodrome (top left), which once
stood on Stamford Street, opening in 1912
and being demolished in 1987 to make
way for offices; the railway station (top
right), a centre of local transport; Stamford
Park (bottom left), a centre of recreation;
Bowdon, St Mary's (bottom right), a centre
of local worship; and the tram terminus
on Railway Street (centre), a transport
hub in the middle of the town. Both
'Multi-views' show us some of the more
important settings within Altrincham.

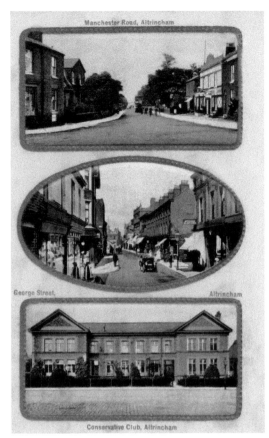

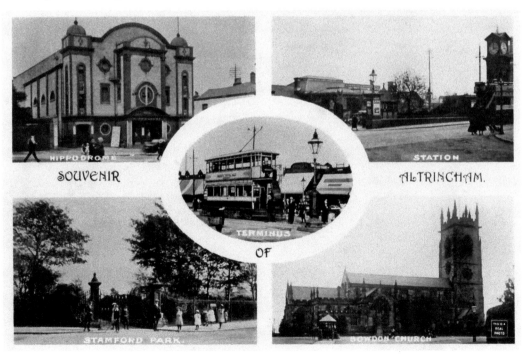

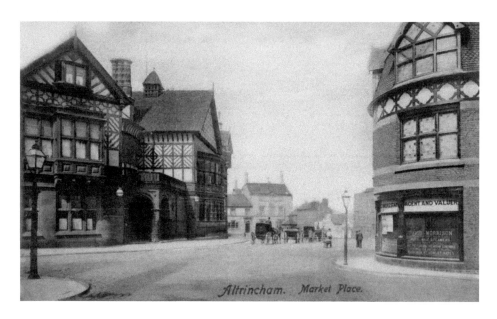

Altrincham. Market Place.

The Old Market Place & Unicorn Hotel, Altrincham, 1908 & 1904

In 1814 Thomas de Quincey (1785–1859) wrote about the Old Market Place in *Confessions of an English Opium Eater* while travelling from Manchester to Chester, describing it thus: 'Fruits, such as can be had in July, and flowers were scattered about in profusion; even the stalls of the butchers, from their brilliant cleanliness, appeared attractive; and the bonny young women of Altrincham were all trooping about in caps and aprons coquettishly disposed' (after Nickson). Altrincham had changed little since his last visit fourteen years earlier. The new buildings that were later constructed here (above & below) were essentially a mix of styles, with chimney stacks that echoed the Tudor period, Baroque balconies, large leaded windows, and stone and wrought iron. The black and white timber framing of this conservation area alludes to the Cheshire 'black and white' used in farm and manor house construction from early medieval times. On the right (above) were the offices of Morrison's Estate Agents.

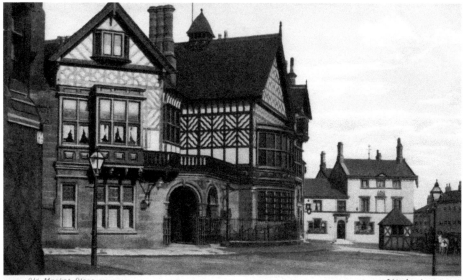

Old Market Place.
(Copyright)

Altrincham.

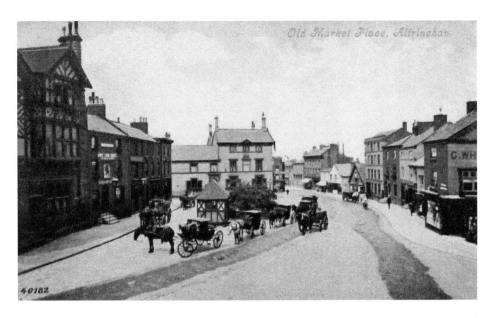

Red Lion & Unicorn Hotels, Old Market Place, Altrincham *c.* 1900 & Manchester Road *c.* 1907

The Red Lion and Unicorn Hotels were built on what was originally a Saxon settlement and site of the Butter Market. The former Lloyd's Bank, the now restored stocks and the Old Market Cross are all located here. The hotels became a stopping point for coaches between Manchester and Chester. Some of these coaches can be seen on the original postcard (above) from around 1900. The Red Lion was used as a billet by the troops of Bonnie Prince Charlie when they came to Altrincham in 1745. The Unicorn Hotel (Old Market Tavern) was built by Lord Delamer as Altrincham's first town hall in 1849. The postcard of Manchester Road (below) is taken from beyond the Unicorn Hotel, on the forecourt of the Wheatsheaf public house and looking towards the George & Dragon public house on the right. Looking towards Timperley and Manchester, there is a tram heading towards the photographer and Altrincham, making the postcard around 1907.

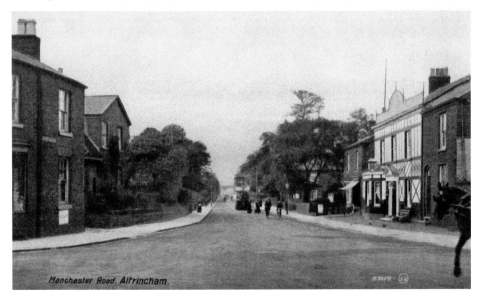

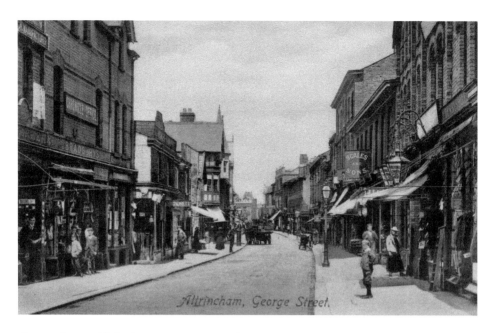

George Street, Altrincham, 1907 & *c.* 1895

Both postcards show one of the principal shopping streets of the town. Some of the businesses seen in these images include Mason's, who were hosiers and hatters, at No. 85; George Roberts & Sons, who traded as butchers at No. 89; and John Ingham, a china dealer, at No. 93. The colour postcard (above) clearly shows us the business interests of Bradbury's, Scales & Sons, and Brundrett's. The Methodist New Connexion chapel and the Salvation Army hall were also located here. Both postcards of this busy shopping area show a curve to the road, which has been 'straightened out' in modern times, with the construction of many new buildings. George Street also has the key modification of being pedestrianised now, so taking traffic around the edges of the main shopping areas of Altrincham.

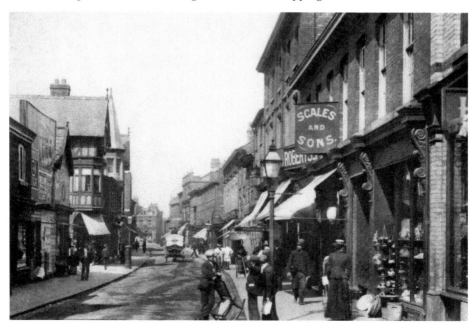

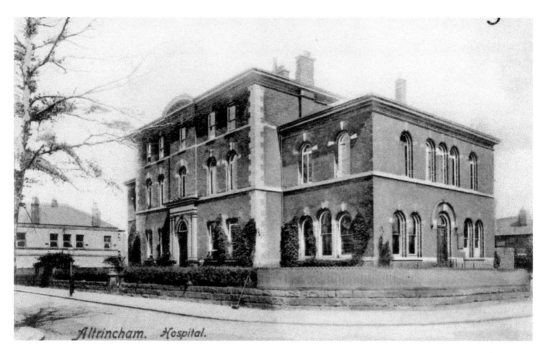

Altrincham. Hospital.

Altrincham Hospital, Regent Road & Market Street Corner *c.* 1900 & Nurses' Home, Ashton-on-Mersey, 1903

As the nineteenth century progressed Altrincham developed from a market town into a commuter suburb of industrial Manchester. It became an area of great contrasts between the mansions of Manchester's cotton merchants and working-class housing situated at the lower end of Altrincham. A Board of Health report on the housing conditions of the poor (eventually) led to the construction of a new hospital, later incorporated into the old General Hospital. Land was donated by the 7th Earl of Stamford. The colour postcard above shows the old General Hospital, which had been extended over the years, on Market Street around 1900. It has now been replaced by a new modern hospital on Railway Street and the old site redeveloped. The nurses' home (below) in Ashton-on-Mersey provided welcome accommodation.

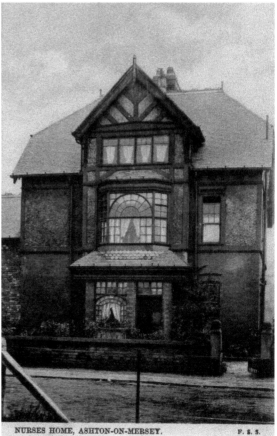

NURSES HOME, ASHTON-ON-MERSEY. F. S. S.

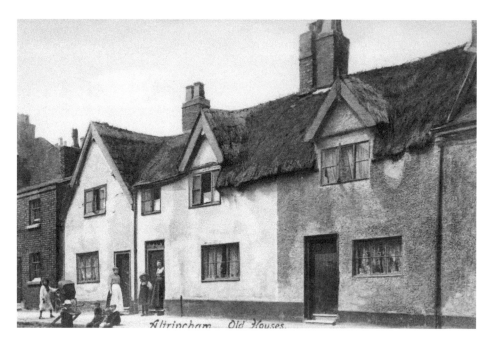

'Old Houses', Lower George Street, Altrincham, 1905, & Rostherne Cottages *c.* 1900
Lower George Street (above) was originally known as Well Street, with the sixteenth-century thatched cottages illustrated on the postcard opposite the old library and the police 'lock-ups'. These dated from 1838. A locally well-known 'Big Well' was located at Well Lane, later known as Victoria Street. One of the cottages was occupied by William Ashley, an Overseer of the parish. All these structures were demolished in the late 1970s when Petros Developments built the modern shopping centre. Rostherne Cottages (below), by S. Butler of Altrincham, are further examples of Altrincham's rural heritage. Rostherne is a village located just to the south of Altrincham, bordering onto Bowdon, where there are many Grade II listed examples of cottages, and whose parish church is Grade I listed.

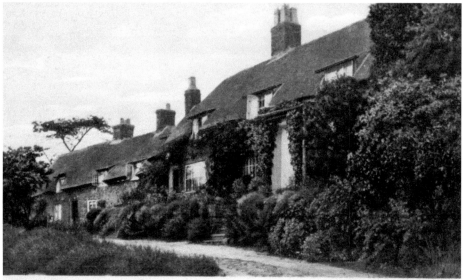

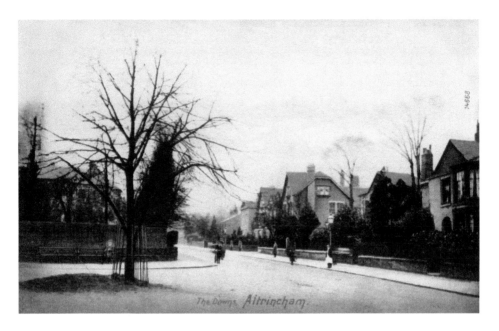

The Downs, Altrincham, 1907 & Delamer (Delamere) & St John's Crossroads *c.* 1950
This colour postcard emphasises the Downs (above) as an essential residential area of Altrincham. Growth began in the 1840s, with the arrival of the railway and commuters. They were attracted by the clean air and tranquillity of areas like the Downs. The first residential properties to be constructed were terraced and semi-detached houses, but by the 1860s and '70s large villas were being built at places like Green Walk, which remain a feature today. These became the dwellings of the affluent merchant class. Many original features remained into the twentieth century, as can be seen from the gas lamps in the 1950s postcard of nearby Delamer Road (below). Note also the authentic 1950s motor transport close to the road junction. Delamer Road is named after George Booth, the 1st Lord Delamer.

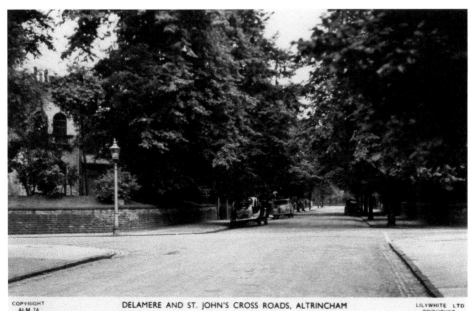

DELAMERE AND ST. JOHN'S CROSS ROADS, ALTRINCHAM

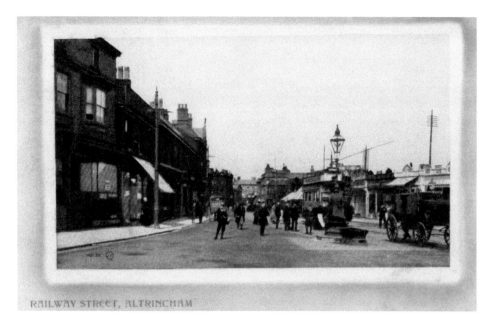

RAILWAY STREET, ALTRINCHAM

Railway Street looking towards Altrincham, 1911, & looking towards Bowdon, 1907
Opened on 22 September 1849, the Bowdon terminus of the Manchester, South Junction
& Altrincham Railway, behind the shops on the left and shown on the postcard of 1907
below, became car sheds on the closing of the facility in 1881. Later, in 1931, the depot was
made ready for the electrification of the Altrincham to Manchester route. The site closed in
December 1991, becoming a car park, as Metrolink did not require it for their services. In
1907 it was an engine shed surrounded by retail premises. It is now the site of Altrincham
Hospital. The spire belongs to St John the Evangelist parish church. The postcard of 1911
(above) shows a tram at the terminus on Railway Street and looks towards Altrincham town
centre. Coincidentally, the first tram in Altrincham made its inaugural journey in 1907.

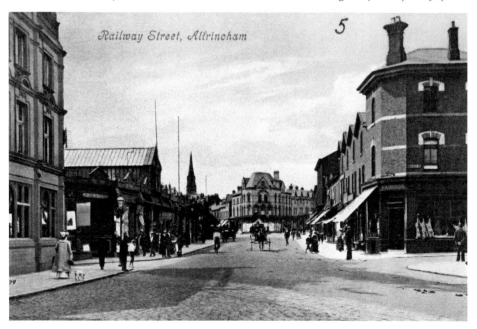

Railway Street, Altrincham

5

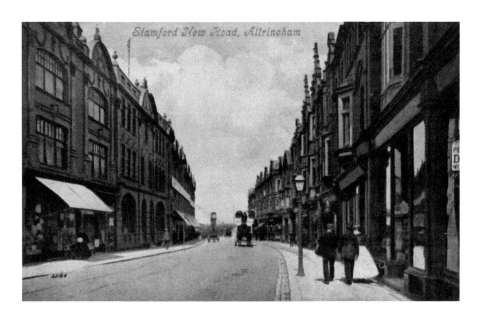

Stamford New Road, Altrincham, 1908, & Station Buildings (Stamford House) *c.* 1915
Stamford New Road was constructed around 1880, giving Railway Street direct access to
the railway station. Several cottages, the Old Orange Tree public house and the thatched
Faulkner's Arms were demolished. Two 'modern' hotels were built in their place, on both
sides of the new road. The Faulkner's Arms retained its name, opposite the Stamford Hotel.
The station clock tower, built 1880, remains as a Grade II listed structure. J. H. Brown
(Broun in some sources) developed land along Ashley Road and also built Station Buildings
(Stamford House). The land here originally consisted of orchards and vegetable gardens,
which bordered both sides of the road as late as 1890. The colour postcard of Stamford
New Road in 1908 (above) shows us a horse-drawn omnibus (centre). The upper deck of the
omnibus is open to the elements, and an umbrella is in use! Despite the postmark of 1908
there appears to be no evidence of a tram, whilst below dates to around 1915.

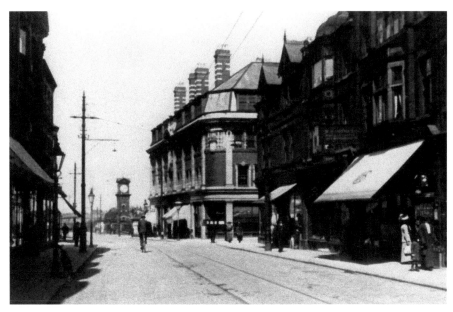

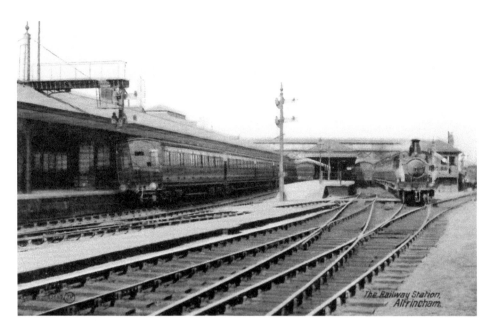

Altrincham Railway Station, Stamford New Road, *c.* 1900 & 1881

Altrincham station was originally serviced by a goods yard, which closed on 8 October 1966, with the level crossing closing on 30 October 1978, replaced by a bridge carrying the A560. Manchester to Altrincham electric trains ceased on 24 December 1991, with platforms one and two later reopening for Metrolink trams. A new roof for platform one was constructed in 2006. Altrincham Interchange has four platforms in total, with two through-platforms for services between Manchester Piccadilly and Chester, via Stockport. The Interchange was completely redeveloped, officially reopening on 7 December 2014. The colour postcard above shows the interior of the station, whilst the black and white postcard of 1881 below is taken from the same angle but also gives a view of the goods yard in the foreground. There is a good selection of rolling stock shown on both postcards.

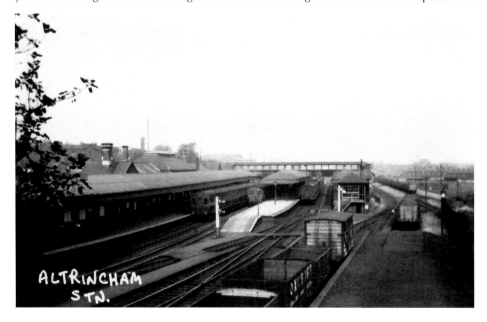

St Margaret's Parish Church, Dunham Road, Altrincham, 1916, & War Memorial *c.* 1930

On 11 April 1855 St Margaret's became the district church for parts of the township of Dunham Massey and Altrincham, which were previously served by St Mary's, Bowdon. It later included the chapel of Dunham Massey, All Saints. On 5 November 1867 St Margaret's boundaries were reduced when part of the township of Dunham Massey was transferred to the new district of Altrincham, St John the Evangelist. The colour postcard above gives us a close-up view of the church from Dunham Road (Chester Road) complete with its spire, which had been demolished by the time the view below was taken around 1930. The war memorial can be seen, which was later removed when Dunham Road became busier with motor traffic, to a safer and more accessible location.

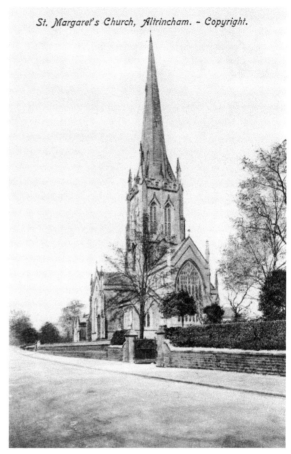

St. Margaret's Church, Altrincham. - Copyright.

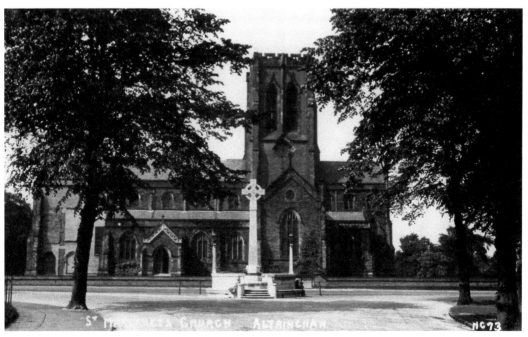

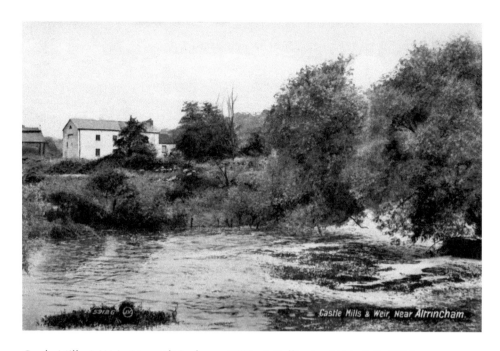

Castle Mills & Weir, Near Altrincham, 1909, & Bollington Waterfall, 1912

The River Bollin runs to the south of Altrincham and provides Edwardian children with a source of amusement on sunny summer days. Castle Mills is near Ashley Mill, where Castle Mill Lane crosses the River Bollin at the weir close to Ringway (shown in the above postcard image). The unusual colour postcard below shows the River Bollin at Little Bollington, where it is known as Crump Weir. The weir, little changed today, formed part of the water management system for Little Bollington Mill, constructed on the banks of the River Bollin. The manor of Little Bollington is mentioned in the Domesday Survey of 1086, whilst documents dated to 1353 refer to a manorial corn mill in the district. The present mill dates to the 1860s and is a Grade II listed building.

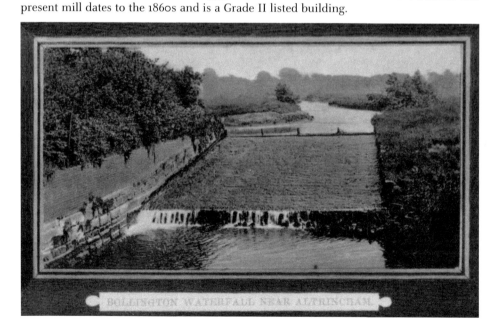

BIBLIOGRAPHY AND SOURCES

Archives & Local Studies, Central Library, St Peter's Square, Manchester.

Billington, M., *The Story of Flixton, Urmston and Davyhulme* (Stroud: The History Press, 2018)

Cliff, K. & V. Masterson, *Images of England. Urmston, Flixton and Davyhulme* (Stroud: Tempus, 2000)

Crossland, A., *Looking Back at Urmston, including Flixton and Davyhulme* (Altrincham: Willow, 1983)

Dickens, S., *Sale Through Time* (Stroud: Amberley. 2013); *Flixton, Urmston & Davyhulme Through Time* (Stroud: Amberley, 2013); *Stretford & Old Trafford Through Time* (Stroud: Amberley, 2014); *Chester to Manchester Line Through Time* (Stroud: Amberley, 2016); *Altrincham Through Time* (Stroud: Amberley, 2016); *Manchester Ship Canal Through Time* (Stroud: Amberley, 2017) *Altrincham in 50 Buildings* (Stroud: Amberley, 2018)

Hainsworth, V., *Looking Back at Sale* (Altrincham: Willow, 1983)

Langton, D. H., *A History of the Parish of Flixton, Comprising the Township of Flixton and Urmston, with a Short Sketch of the adjoining Hamlet of Davyhulme* (Manchester: Taylor, Garnett, Evans & Co., 1898)

Lawson, R., *A History of Flixton, Urmston and Davyhulme* (Urmston: Richard Lawson, 1898)

Massey, S., *A History of Stretford* (Manchester: Sherratt & Son, 1976)

Masterson, V. & K. Cliff, *Stretford: An Illustrated History* (Derby: Breedon, 2002)

Morrison, B. D., *Looking Back at Altrincham* (Timperley: Willow Publishing, 1980)

Nicholls, R., *Trafford Park: The First Hundred Years* (Chichester: Phillimore & Co., 1996)

Nickson, C., *Bygone Altrincham: Traditions and History* (Altrincham: Mackie & Co. Ltd, 1935)

Swain, N. V., *A History of Sale-from earliest times to the present-day* (Wilmslow: Sigma, 1987)

Trafford Local Studies Centre, Town Hall, 1 Waterside Plaza, Sale. M33.7ZF

www.urmston.net

ABOUT THE AUTHOR

Steven is a retired charge nurse and college lecturer who is married to Sarah. They live in Flixton and have three sons and three daughters. He has written several *Through Time* volumes. In this *Postcard Collection* he looks at the Metropolitan Borough of Trafford, its history and heritage. Steven has always had an interest in local history and genealogy and has an academic background in modern history. He has previously written several journal and magazine articles on these themes.